ULTIMATE COLORING

AMERICA THE BEAUTIFUL
COLOR FROM SEA TO SHINING SEA

D1532172

PORTABLE
PRESS

San Diego, California

"America the Beautiful" (1910)

Lyrics from the 1893 poem by Katharine Lee Bates

O beautiful for spacious skies,
For amber waves of grain,
For purple mountain majesties
Above the fruited plain!
America! America!
God shed his grace on thee,
And crown thy good with brotherhood
From sea to shining sea!

O beautiful for pilgrim feet,
Whose stern, impassioned stress
A thoroughfare for freedom beat
Across the wilderness!
America! America!
God mend thine ev'ry flaw,
Confirm thy soul in self-control,
Thy liberty in law!

O beautiful for heroes proved
In liberating strife,
Who more than self their country loved,
And mercy more than life!
America! America!
May God thy gold refine,
Till all success be nobleness
And ev'ry gain divine!

O beautiful for patriot dream
That sees beyond the years
Thine alabaster cities gleam,
Undimmed by human tears
America! America!
God shed his grace on thee
And crown thy good with brotherhood
From sea to shining sea!

BALD EAGLE SOARING OVER MOUNTAINS

The bald eagle is a powerful flier, taking advantage of thermals to soar to heights before swooping down to catch its prey—mainly fish—at speeds of up to 99 miles per hour. *Bald* was a word that once meant "white," and the feathers that give the eagle its name appear after about five years, when the eagle is ready to mate.

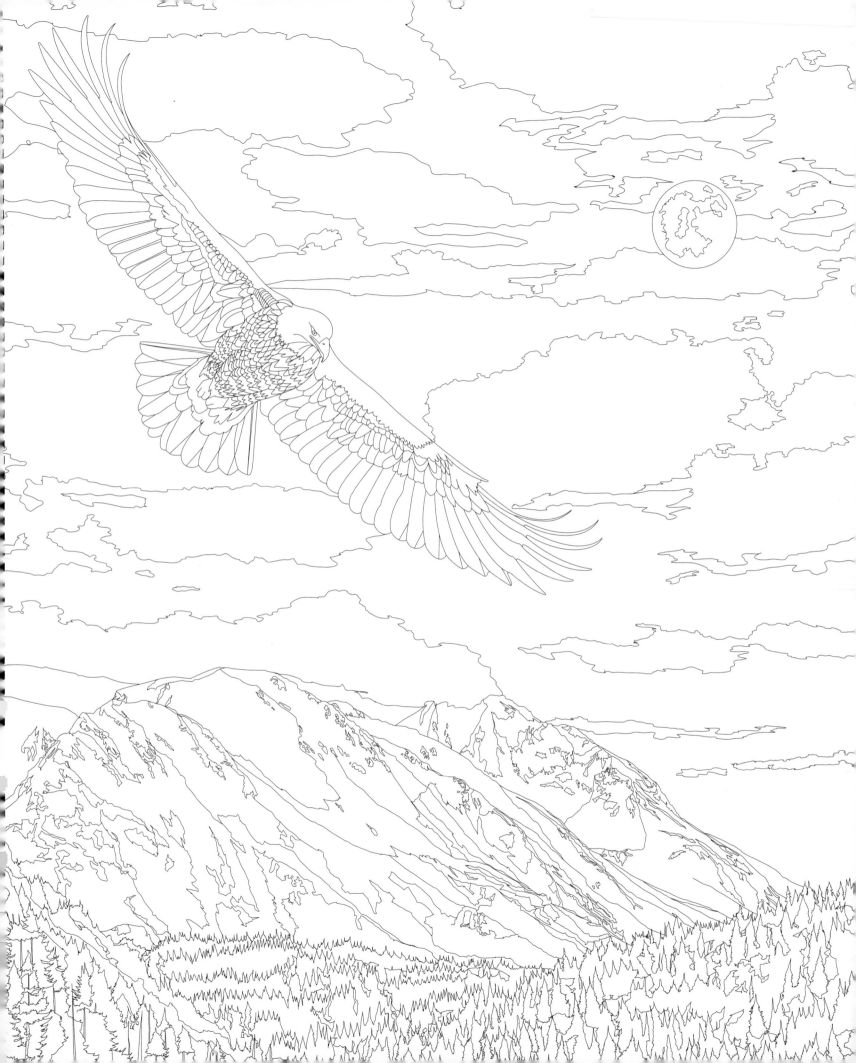

GRAND CANYON, ARIZONA

How old is the Grand Canyon? Geologists are still arguing—maybe 70 million years, maybe much less. What they do agree on, though, is that at least five million years ago the Colorado River established a course through the area. And it's been carving its way through the rock ever since, to create a canyon that today is more than a mile deep and up to 18 miles wide.

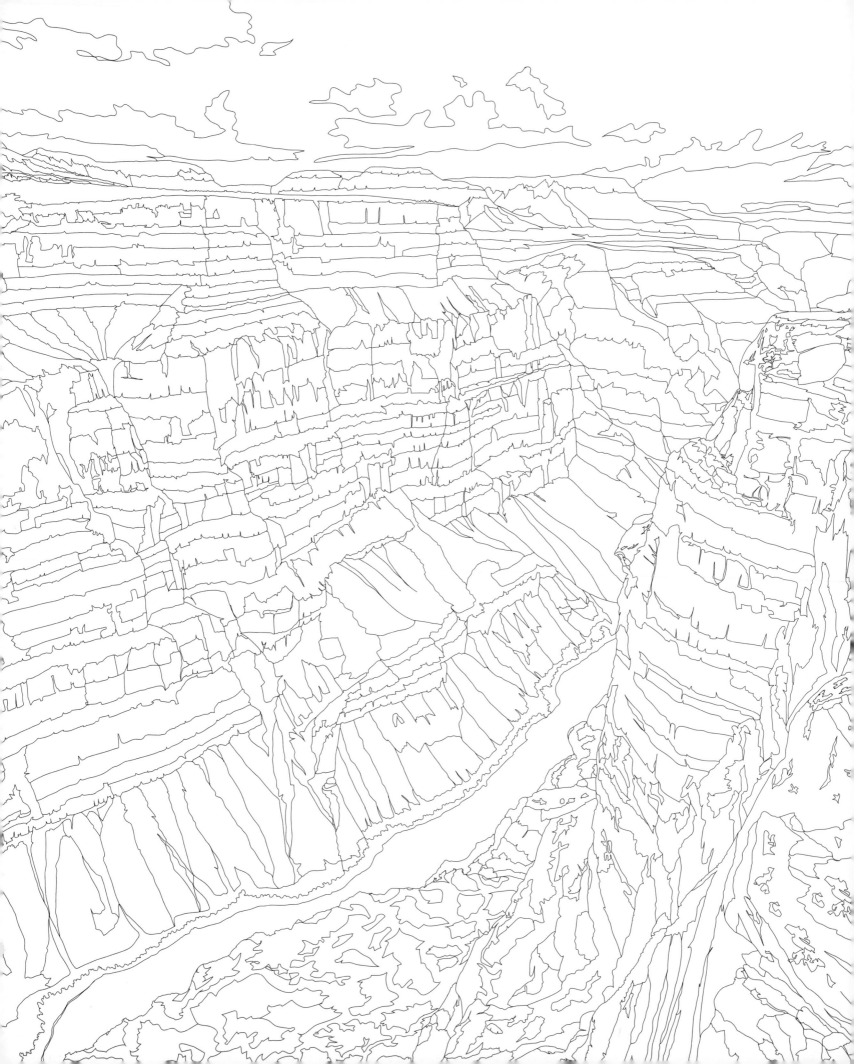

STATUE OF LIBERTY, LIBERTY ISLAND, NEW YORK CITY

Recognizable across the world, the Statue of Liberty is a figure representing freedom and opportunity for all. So it's appropriate that most of the funds raised for its construction came not from government or wealthy individuals but from ordinary New Yorkers contributing what they could afford—usually less than a dollar. At its dedication in 1886, traders from the New York Stock Exchange threw ticker tape from their windows, and a new tradition was born.

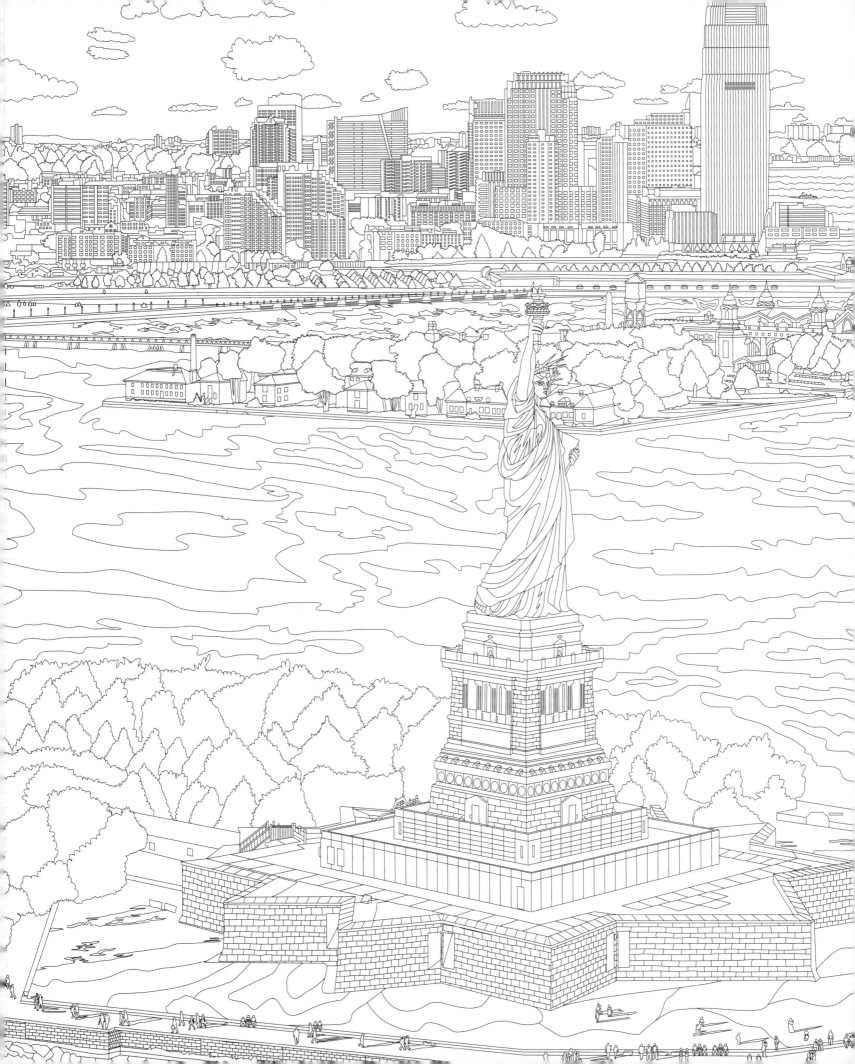

THE LAS VEGAS STRIP, NEVADA

There's Paris, France—and there's Paris, Las Vegas, where the Eiffel Tower is half the size of the French original and the Opera House is the entrance to a hotel. And a ten-minute walk is all it takes to find yourself in Italy—or, at least, at the Bellagio, the resort inspired by the town located on Lake Como. You can also visit the Egyptian pyramid of Luxor further down the Strip.

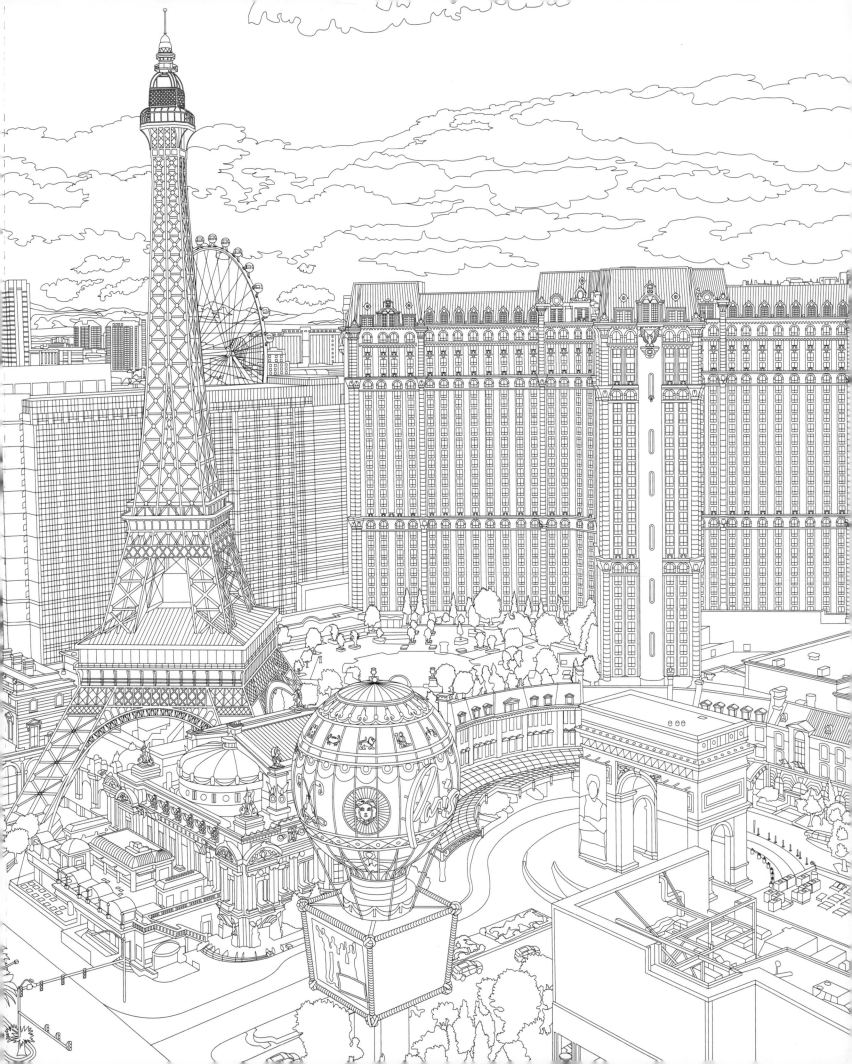

ANNISQUAM HARBOR LIGHT STATION, GLOUCESTER, MASSACHUSETTS

Annisquam means "top of the rock," and a lighthouse has been standing here, a warning to sailors, since 1801. Congress granted the $2,000 required for its completion, and it is one of the oldest lighthouses in Massachusetts. Still in service today, it has been automated since 1974 and is managed by the U.S. Coast Guard, which still uses the original keeper's wooden house.

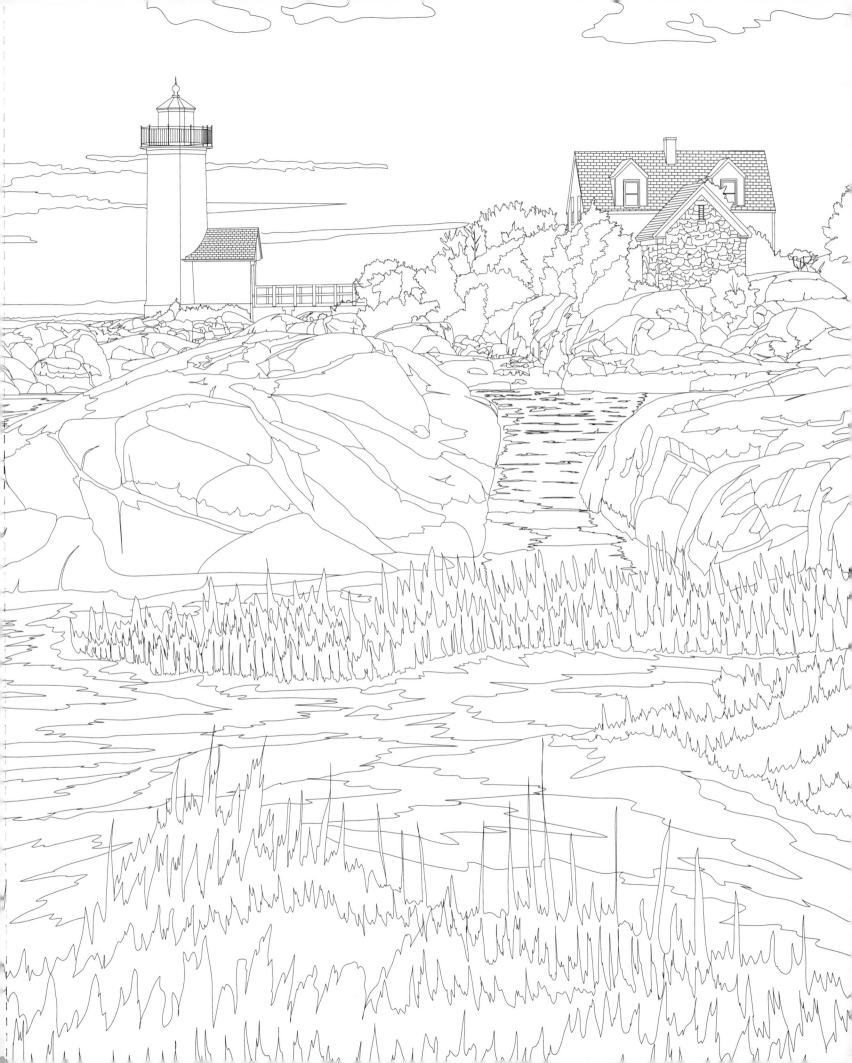

WASHINGTON MONUMENT, NATIONAL MALL, WASHINGTON, D.C.

It stands at more than 554 feet tall and is the world's largest stone structure, but the obelisk that honors the first president of the United States was almost never built. Political fighting stalled construction, funds were difficult to raise, and then the country was torn apart by civil war. By war's end, though, the mutual respect that both sides held for George Washington helped unite the North and South in a common goal: to complete the monument. It was dedicated in 1885.

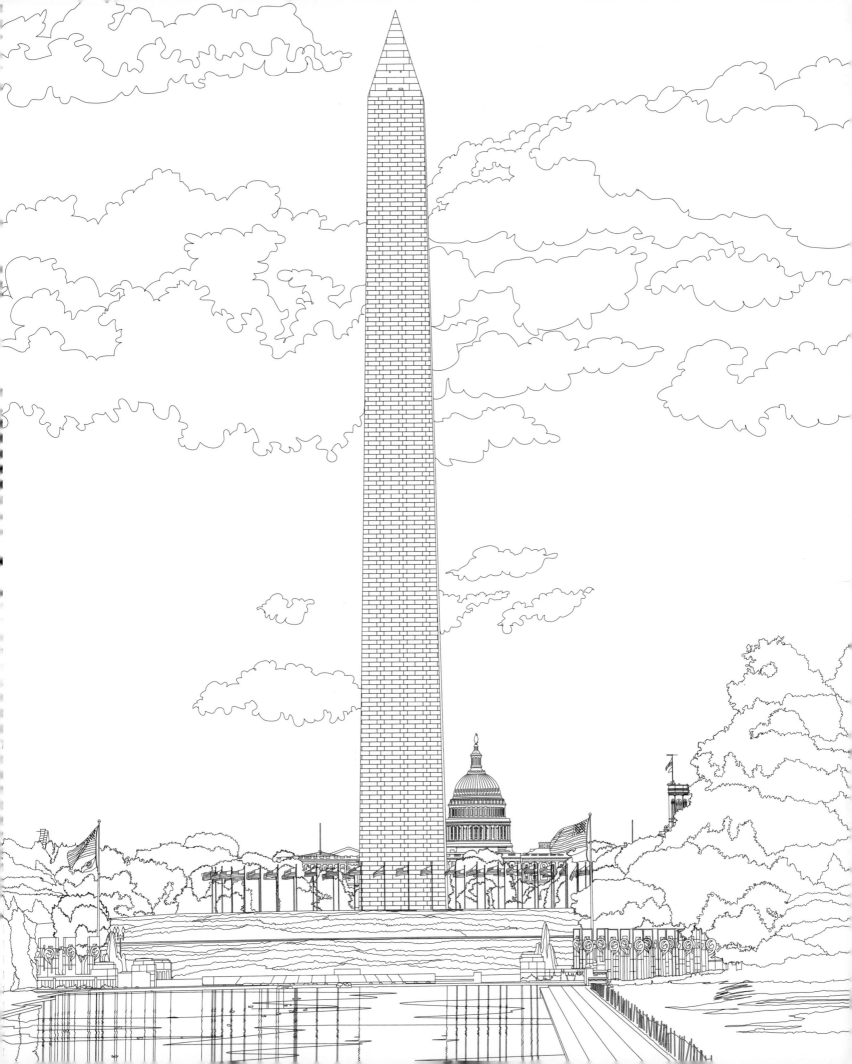

HORSES RIDING ACROSS THE PRAIRIE

Horses used to roam across the plains of North America, but about 10,000 years ago they died out. Only in the sixteenth and seventeenth centuries did horses return, brought by Spanish explorers. Without natural predators, their numbers soon swelled, and there were millions by the mid-1800s. It was hunters who proved the biggest threat, which prompted Congress to pass the first legislation protecting the horses in 1959.

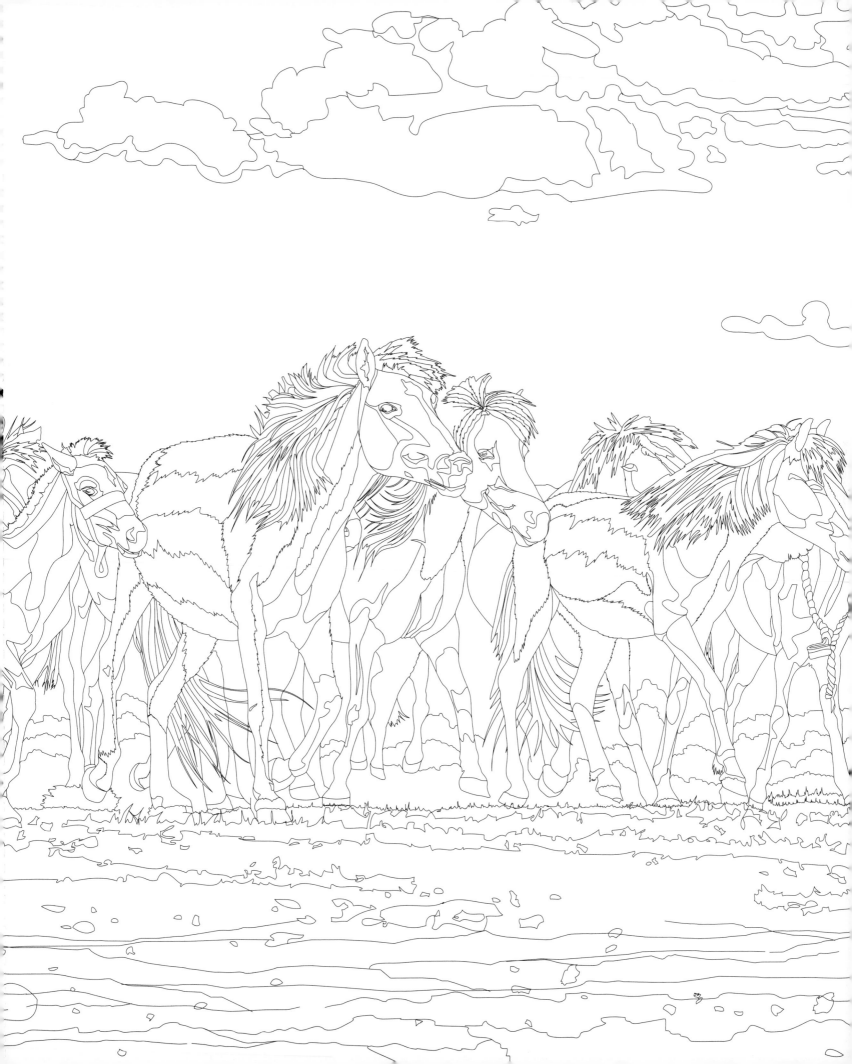

MOUNT RUSHMORE, KEYSTONE, SOUTH DAKOTA

This iconic sculpture began as a way to promote tourism. We might now be looking at the faces of Buffalo Bill or Lewis and Clark had not the sculptor, Gutzon Borglum, insisted on presidents—Washington, Jefferson, Lincoln, and Roosevelt. Work began in 1927 and was completed fourteen years later in the fall of 1941, less than six weeks before the attack on Pearl Harbor.

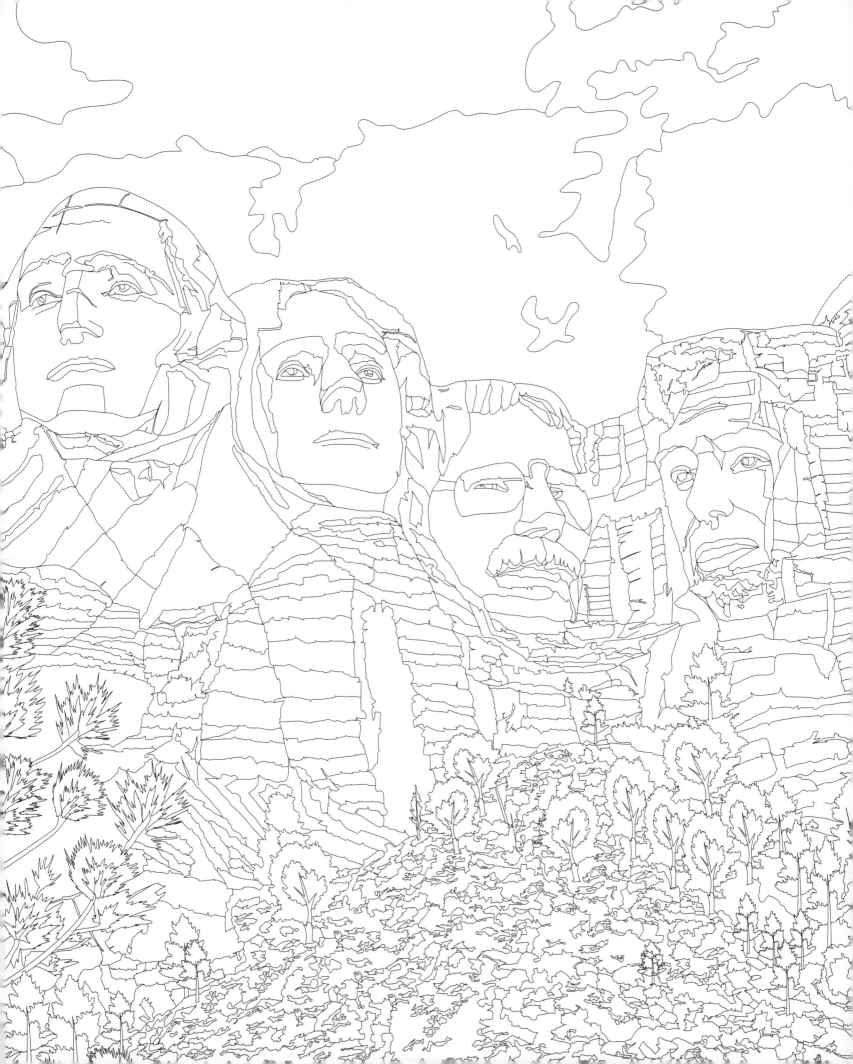

REDWOOD NATIONAL AND STATE PARKS, CALIFORNIA

The tallest tree in the world, the redwood can live for thousands of years. Dating from the Jurassic period, it has survived into the modern age only to be threatened by humans. Logging began in 1850 and was so extensive that calls for conservation began sixty years later. Today, nearly half of all remaining old-growth redwood forests now stand in Redwood National and State Parks.

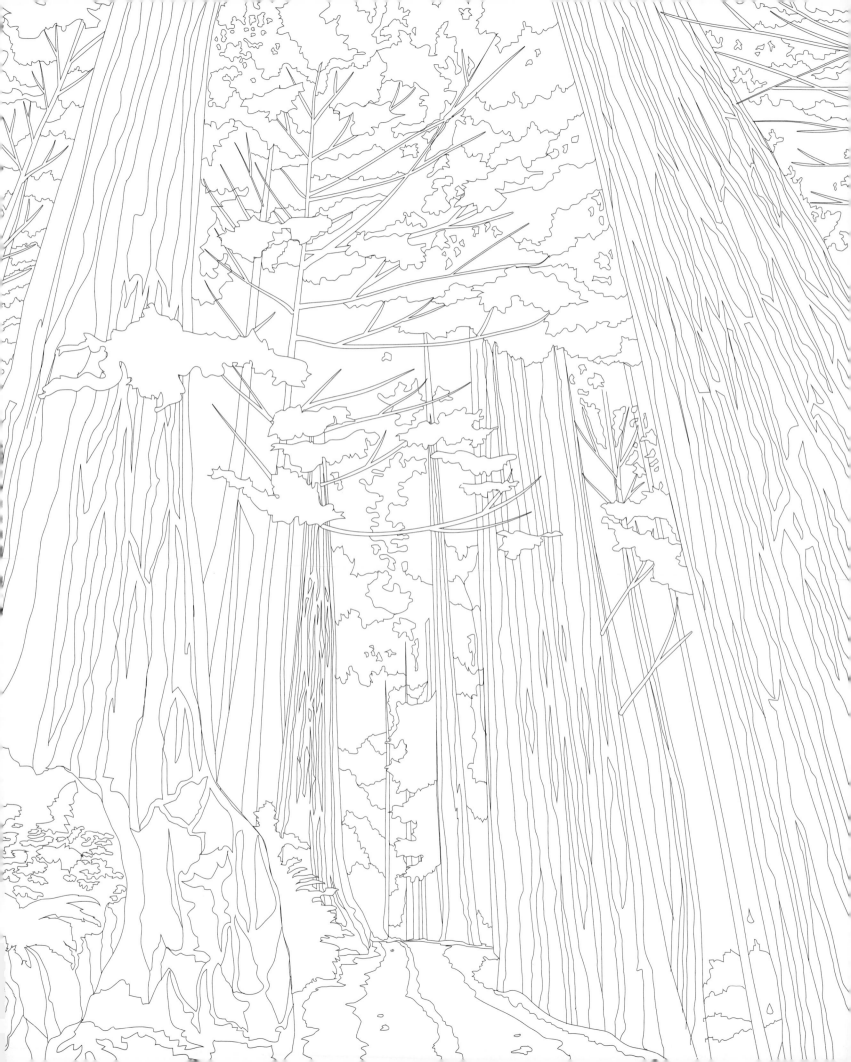

HOLLYWOOD SIGN, MOUNT LEE, CALIFORNIA

The Hollywoodland sign was meant to be temporary; it was a 1923 advertisement for a housing development. But then American movies conquered the world, and the sign became an icon. It even had its own caretaker—who accidentally destroyed the H. The letter was replaced, but LAND was removed. Over the years, the sign continued to deteriorate, and in the 1970s it was restored after a campaign led by *Playboy* founder Hugh Hefner.

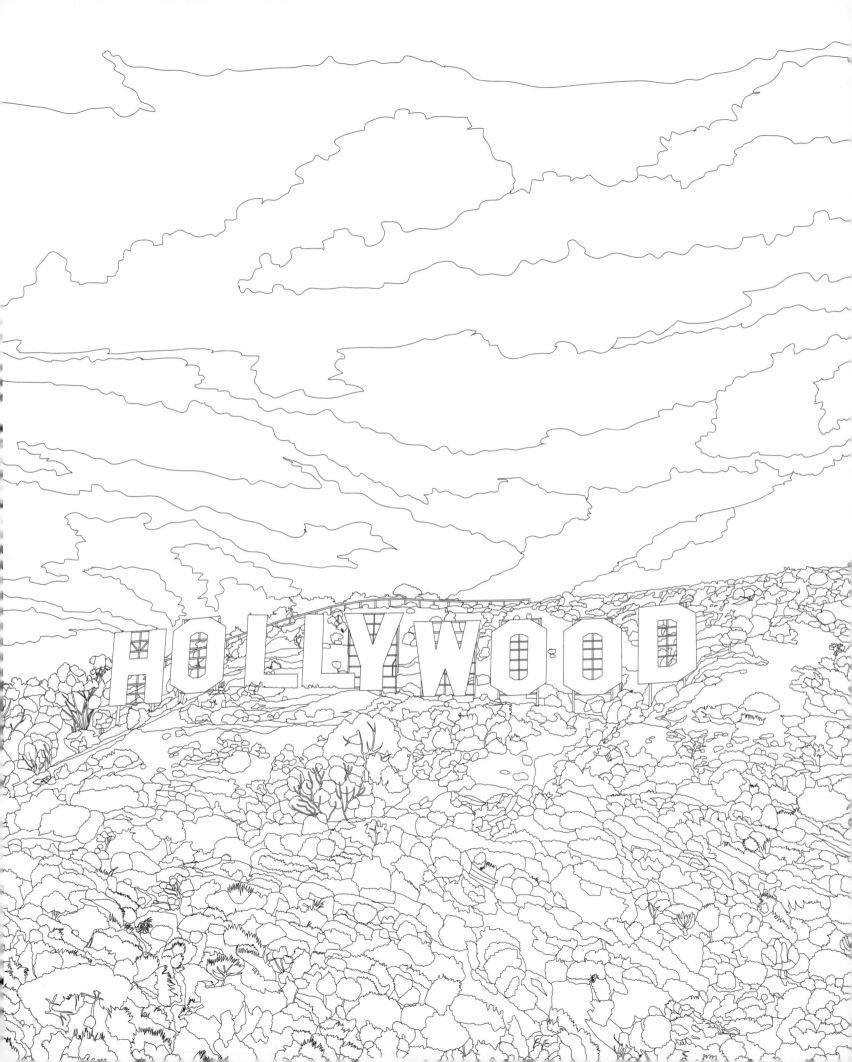

GOLDEN GATE BRIDGE, SAN FRANCISCO/MARIN COUNTY, CALIFORNIA

Before the bridge was opened, the only reliable route from San Francisco across the bay was by boat. A bridge was the obvious solution, but there was intense opposition and more than ten years passed before construction could even begin. The project was eventually completed in 1937 ahead of schedule and under budget, and for more than a quarter-century this Wonder of the Modern World was the longest single suspension bridge in the world, with a span of 4,200 feet.

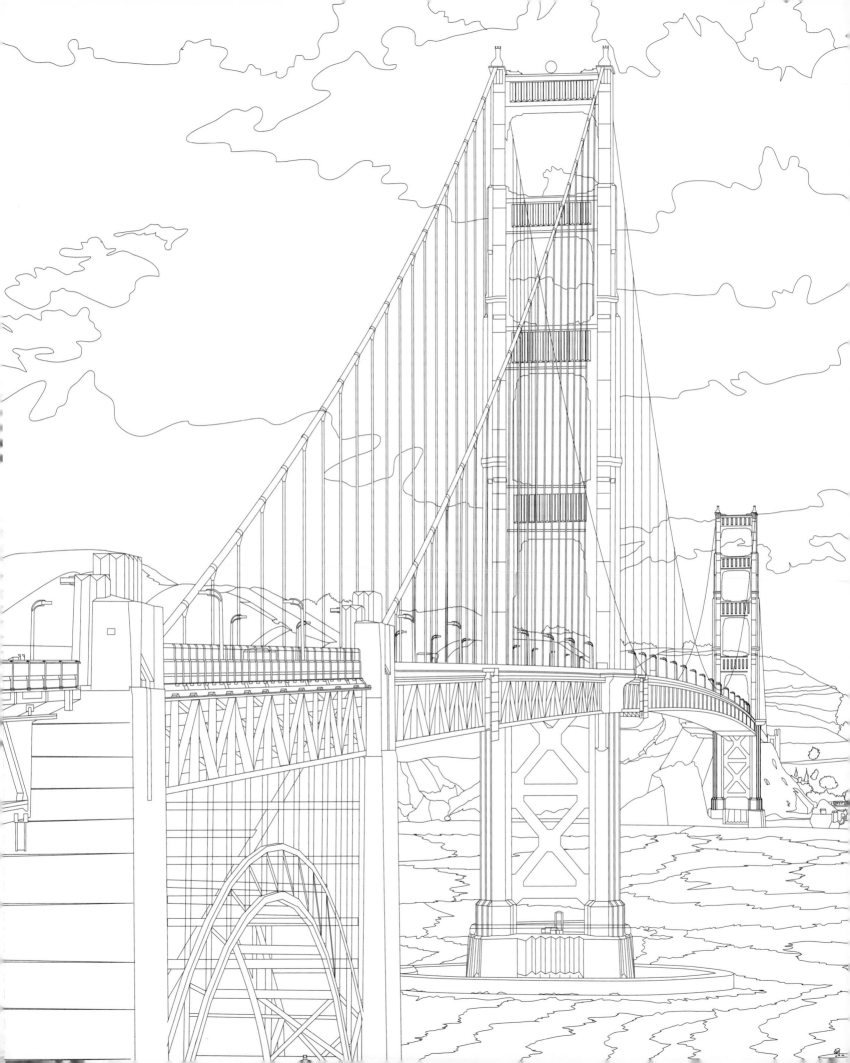

ZABRISKIE POINT, DEATH VALLEY NATIONAL PARK, CALIFORNIA

Zabriskie Point is surrounded by a maze of eroded, strikingly colored badlands. Stand at sunrise or sunset to get the prettiest view of an area that millions of years ago lay under water. Then mountains began forming to the west, and the region became increasingly arid. The lake eventually dried up, leaving behind sediments of mud, gravel, and borates, which form the remarkable landscape we see today.

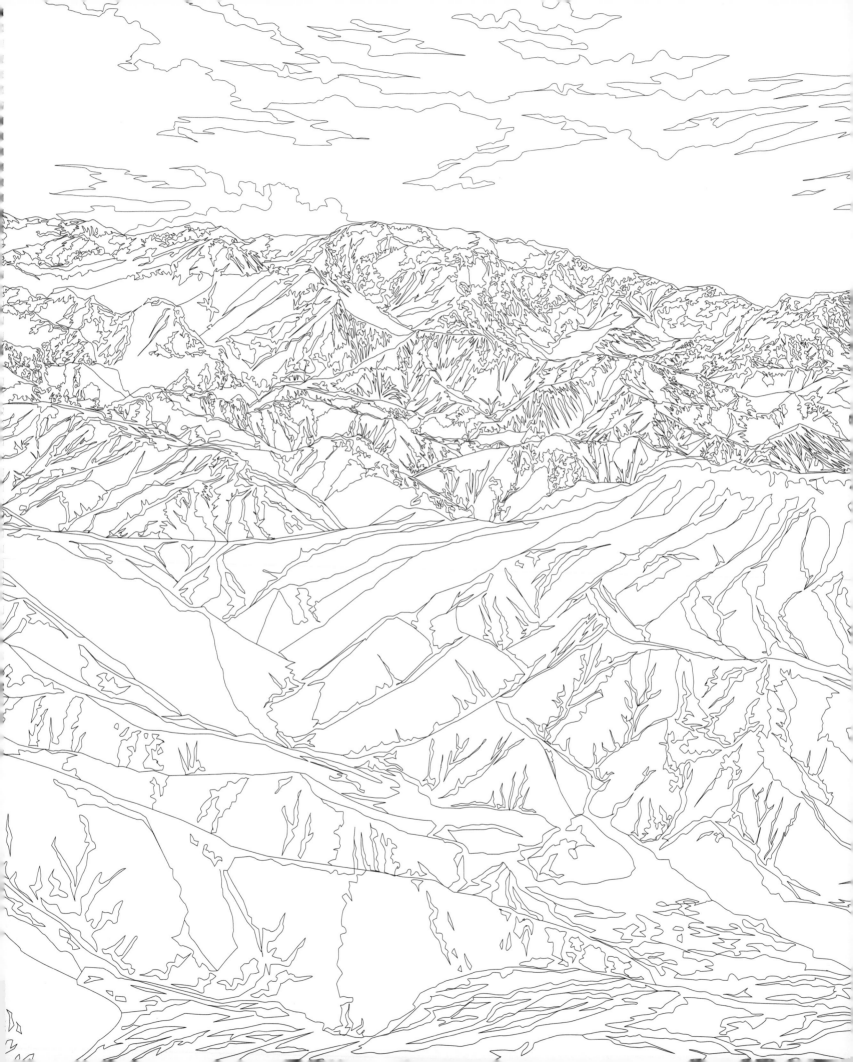

SAGUARO NATIONAL PARK, ARIZONA

The saguaro is a cactus that has been known to grow more than 70 feet tall. Growing very slowly, it may live for up to 150 years. Indeed, any cactus that has formed a sidearm—not all do—is at least 75 (and probably 100) years old. This national park was established specifically to protect the cactus from which it takes its name.

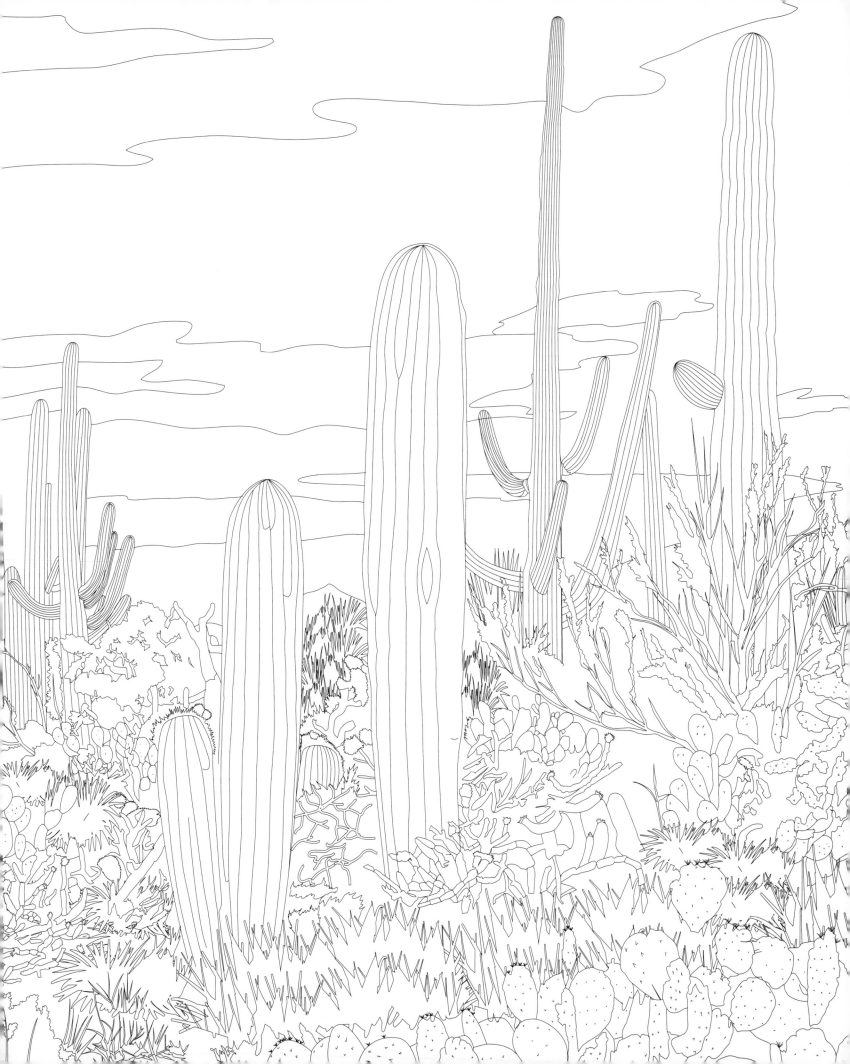

SPACE NEEDLE, SEATTLE, WASHINGTON

Built for the 1962 World's Fair, the Needle was completed in less than a year.
The team worked round the clock, and the final elevator was installed just a day
before the Fair opened. Its foundations are some 30 feet deep and 120 feet
across, and it took a full day to pour the concrete. As a result, it can withstand
winds of up to 200 miles per hour and an earthquake of magnitude 9.1.

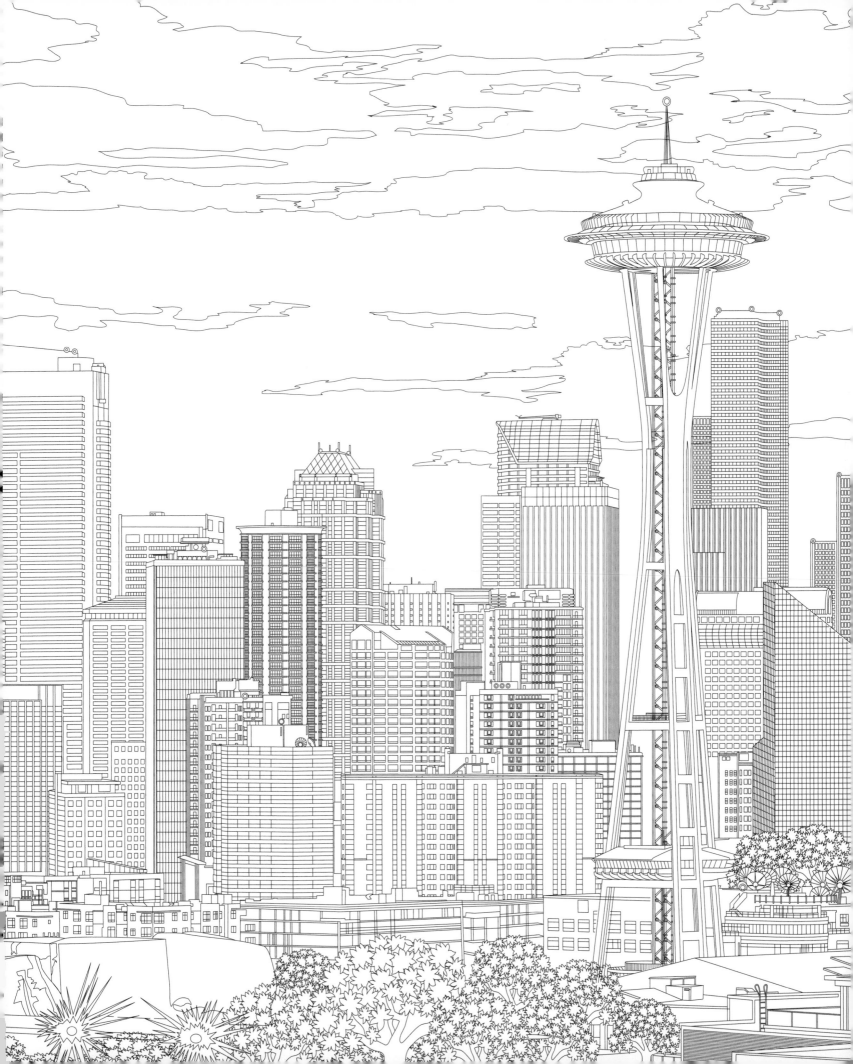

NIAGARA FALLS, NEW YORK

We call them Niagara Falls, but that is actually the name for three waterfalls: the American Falls, the Bridal Veil Falls, and the Horseshoe Falls. They may not be the highest falls in the world, but together they are remarkably wide—3,409 feet. An average of four million cubic feet of water drops every minute, rising to six million at peak flow. Of that flow, 90 percent gushes over Horseshoe Falls on the Canadian side of the falls, while 10 percent tumbles over American Falls on the New York side.

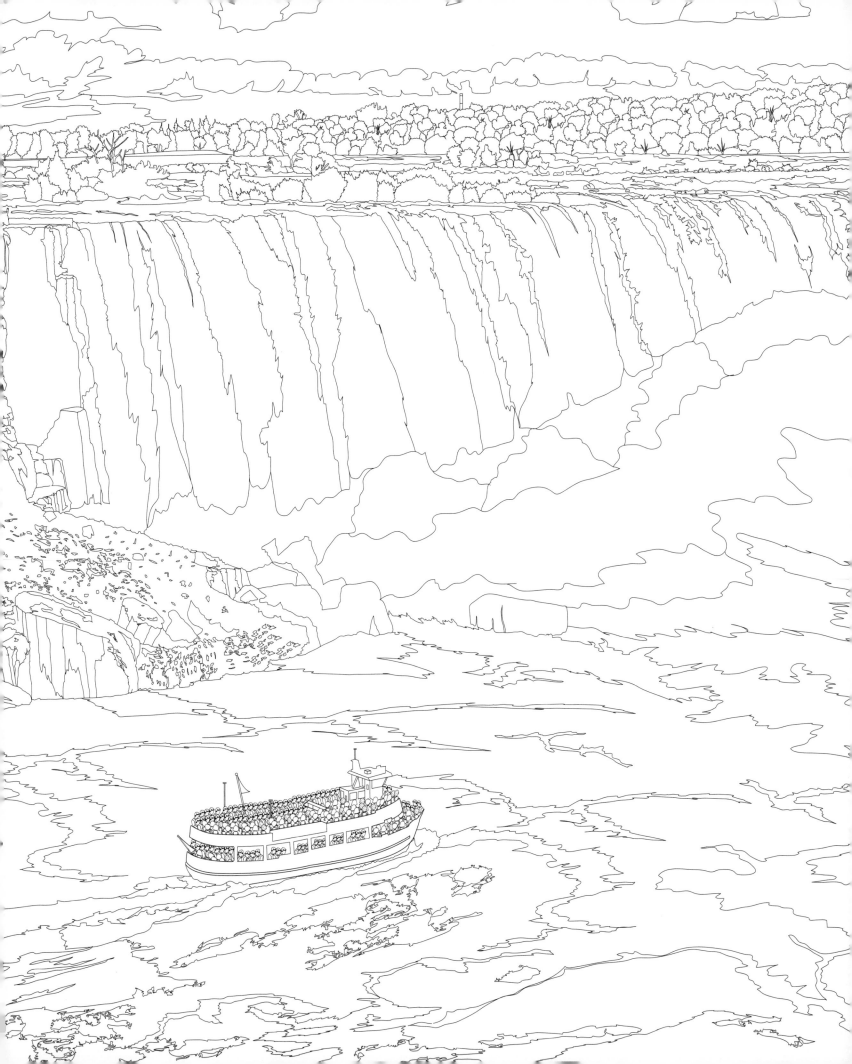

MARTIN DIES JR. STATE PARK, JASPER, TEXAS

Pines, oaks, maples, and magnolias are just some of the trees growing in the forests of Martin Dies Jr. State Park. Walking through them, you'll hear woodpeckers calling and see skunks and lizards scurrying across the ground. There are five species of venomous snakes, too. A reservoir runs alongside the park, so it's possible that you'll see alligators and turtles, and if you camp you'll hear frogs singing come nightfall.

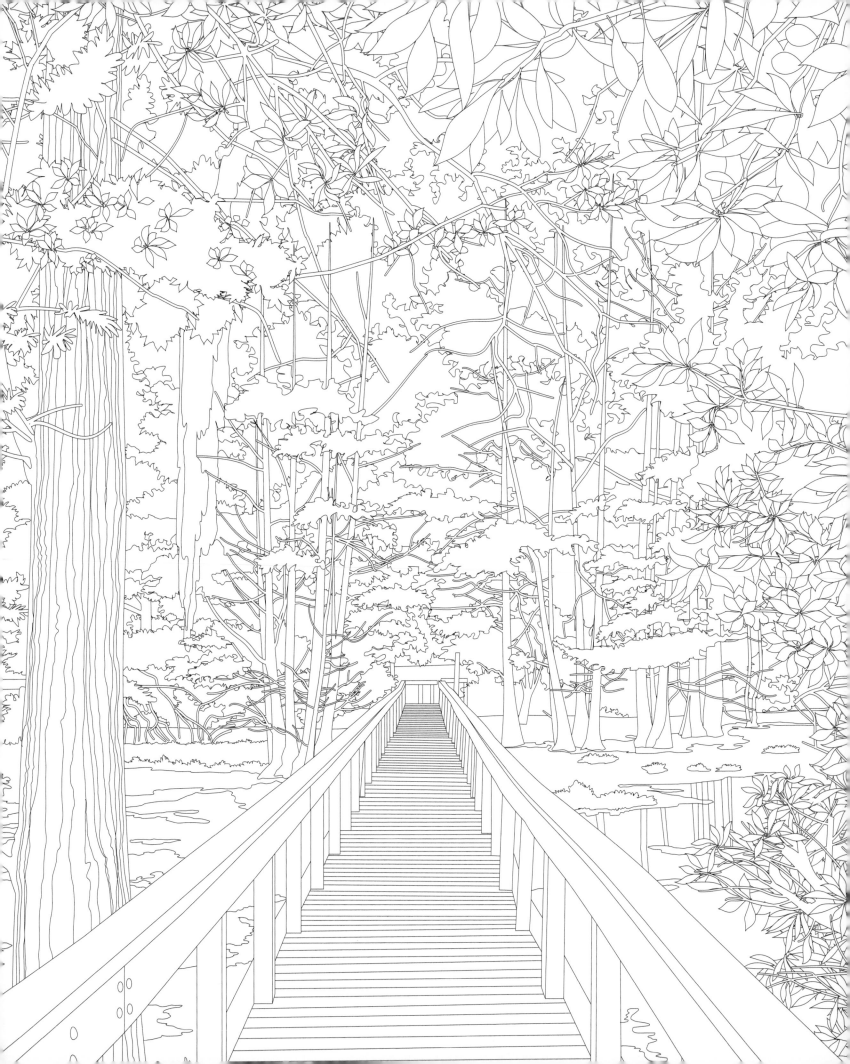

ANNUAL RED MOUNTAIN EAGLE POW-WOW, SCOTTSDALE, ARIZONA

The pow-wow is an opportunity for Native Americans to meet and to honor their culture. Often the dancers perform the same dances handed down from their ancestors. The regalia they wear may also be traditional—made of cloth and leather and featuring customary designs—but modern materials and brilliant colors may also be incorporated. Some dances are competitive, with significant prize money at stake.

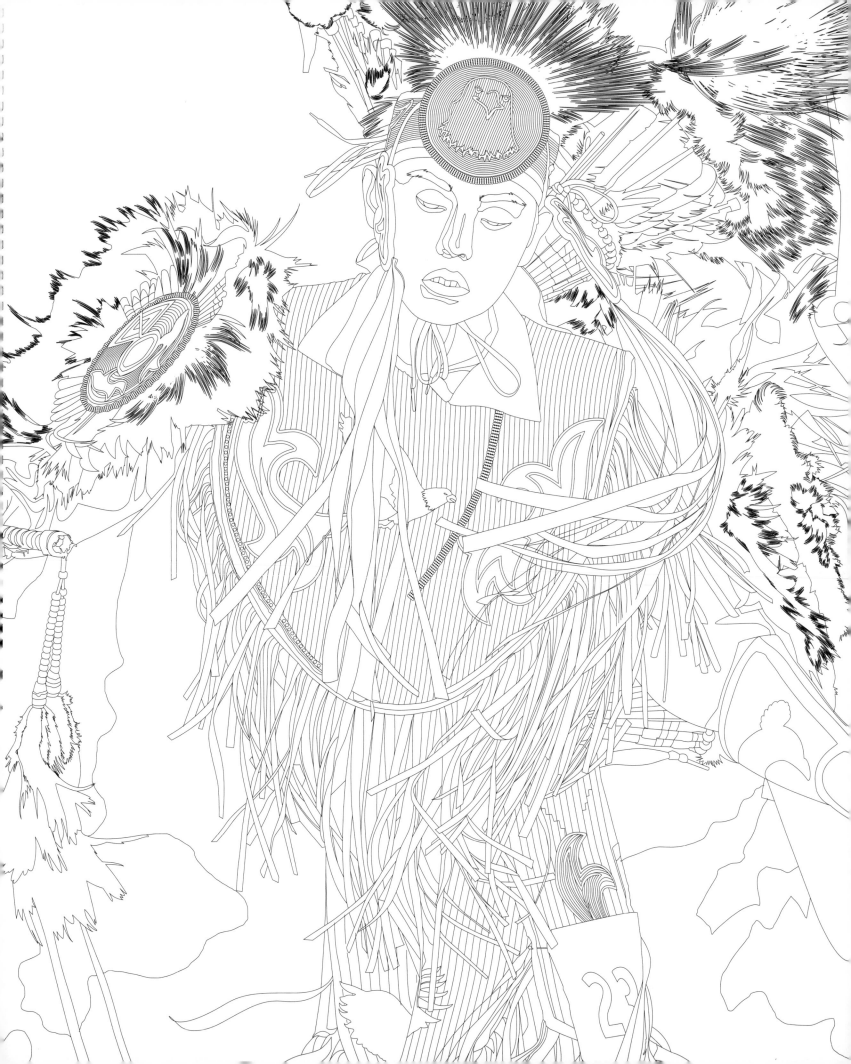

SNAKE RIVER, GRAND TETON NATIONAL PARK, WYOMING

There is evidence that humans have lived in the region of Grand Teton National Park for at least 11,000 years. Snake River, though, takes its name from a modern misunderstanding. This river is a traditional spawning ground for Pacific salmon— good news for the Shoshone people who lived and fished along the river. An attempt to communicate as much by hand signals was misunderstood by European settlers, who believed they were being warned of the presence of snakes.

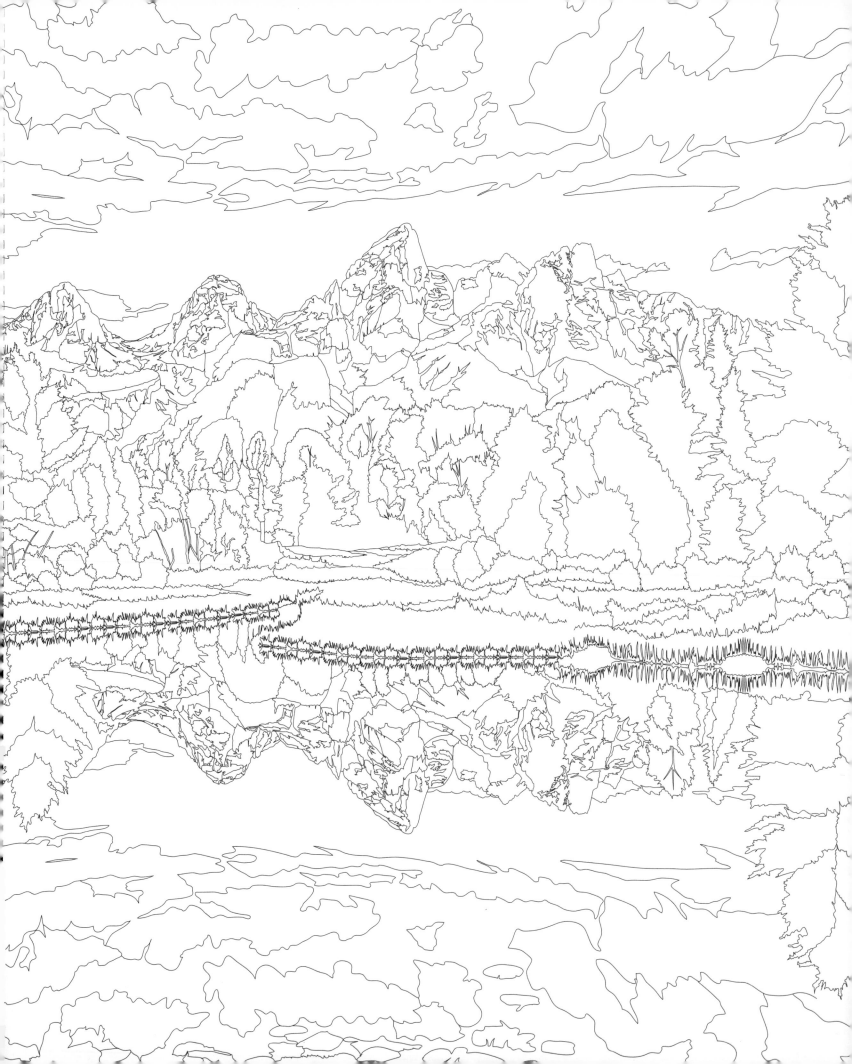

BLACK-TAILED PRAIRIE DOGS, ARIZONA-SONORA DESERT MUSEUM

They are ground squirrels who live in burrows and eat mainly plants—but their warning call sounds like a dog barking. Hence their name, which came courtesy of French settlers if the journals of Lewis and Clark are correct. Prairie dogs are found across North America, including Saguaro National Park's Arizona-Sonora Desert Museum, a site that also hosts more than 230 animal species and 1,200 varieties of plants.

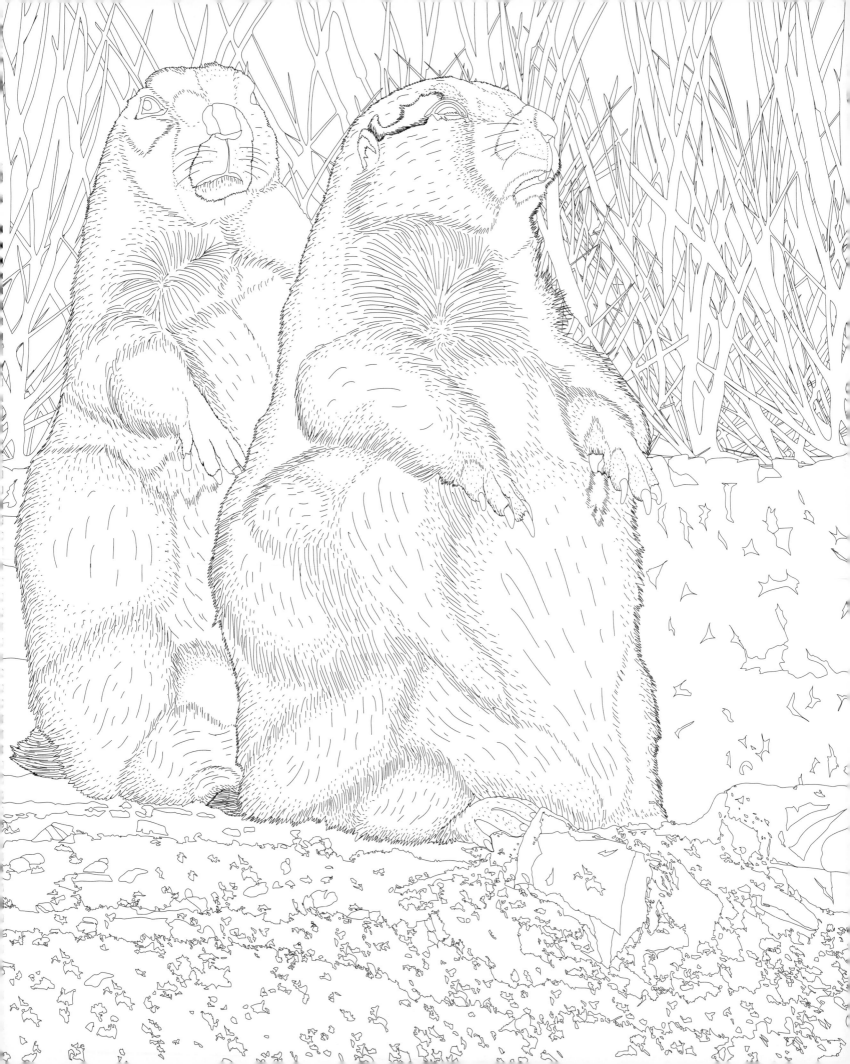

SKAGIT VALLEY TULIP FESTIVAL, WASHINGTON

In the 1890s, farmer George Gibbs dug up some tulip bulbs he had planted just two years earlier in his orchard on Orcas Island. They had multiplied to a remarkable extent, and he now saw an opportunity. Thus began the bulb growing industry in a region that remains the biggest tulip growing center in North America. Running through the month of April, the Skagit Valley Tulip Festival offers glorious displays of color, which change each year as crops rotate.

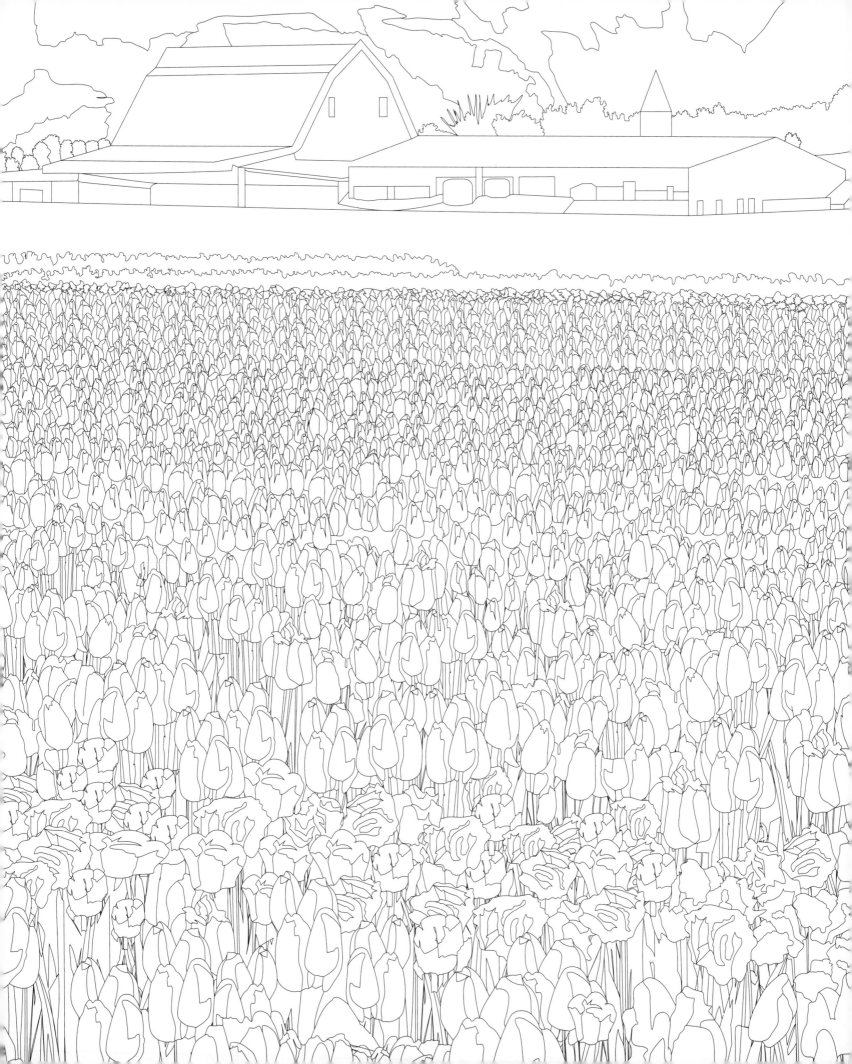

GATEWAY ARCH, ST. LOUIS, MISSOURI

At 630 feet, the Gateway Arch is the world's tallest arch and a symbol of St. Louis—and like so many monuments, it was built despite intense opposition. It was the brainchild of Luther Ely Smith, a civic leader who saw a chance to create jobs during the Great Depression, and whose own daughter pointed out that people needed "more practical things." Not until 1947 did the competition even open for the design, which honors the westward expansion of the United States.

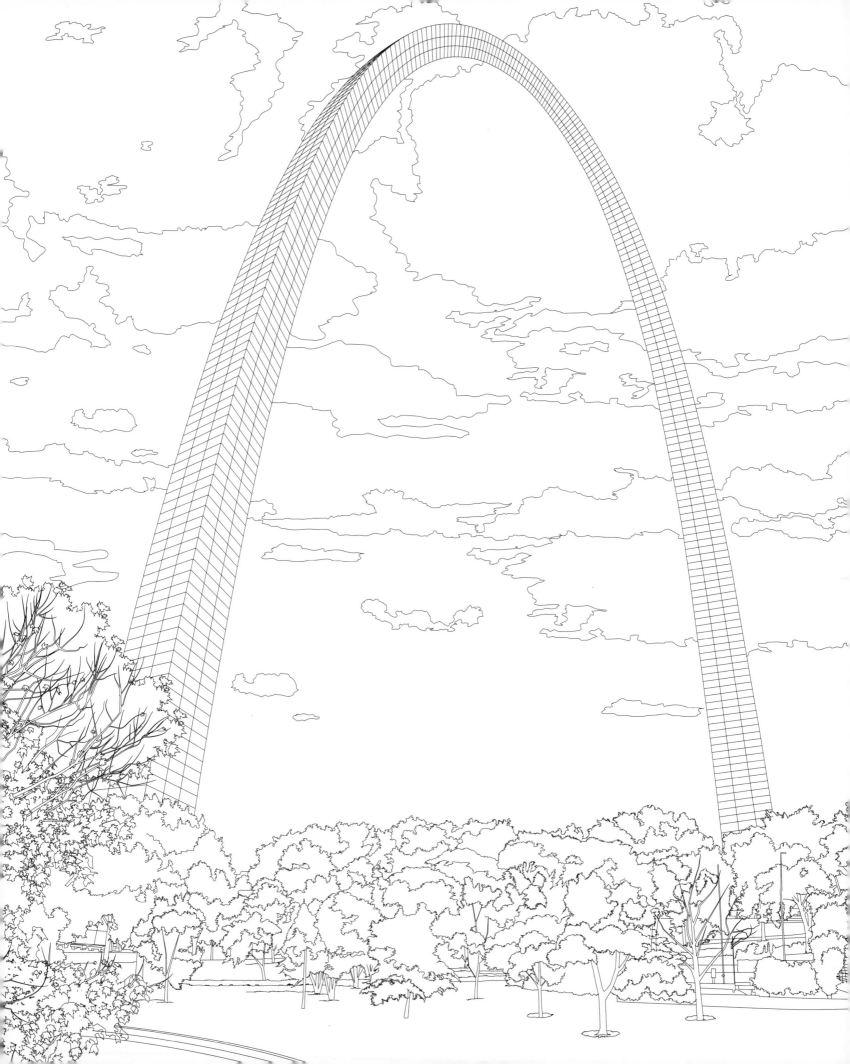

ROAN MOUNTAIN, NORTH CAROLINA/TENNESSEE BORDER

Roan Mountain is home to the largest natural rhododendron garden in the world. Both feature in the legends of the Catawba people, who claim that the mountaintop was left bare of trees and the rhododendrons stained crimson after a fierce battle with the Cherokee. Archeologists have found evidence of numerous settlements at the base of the mountain, which is part of the Appalachians.

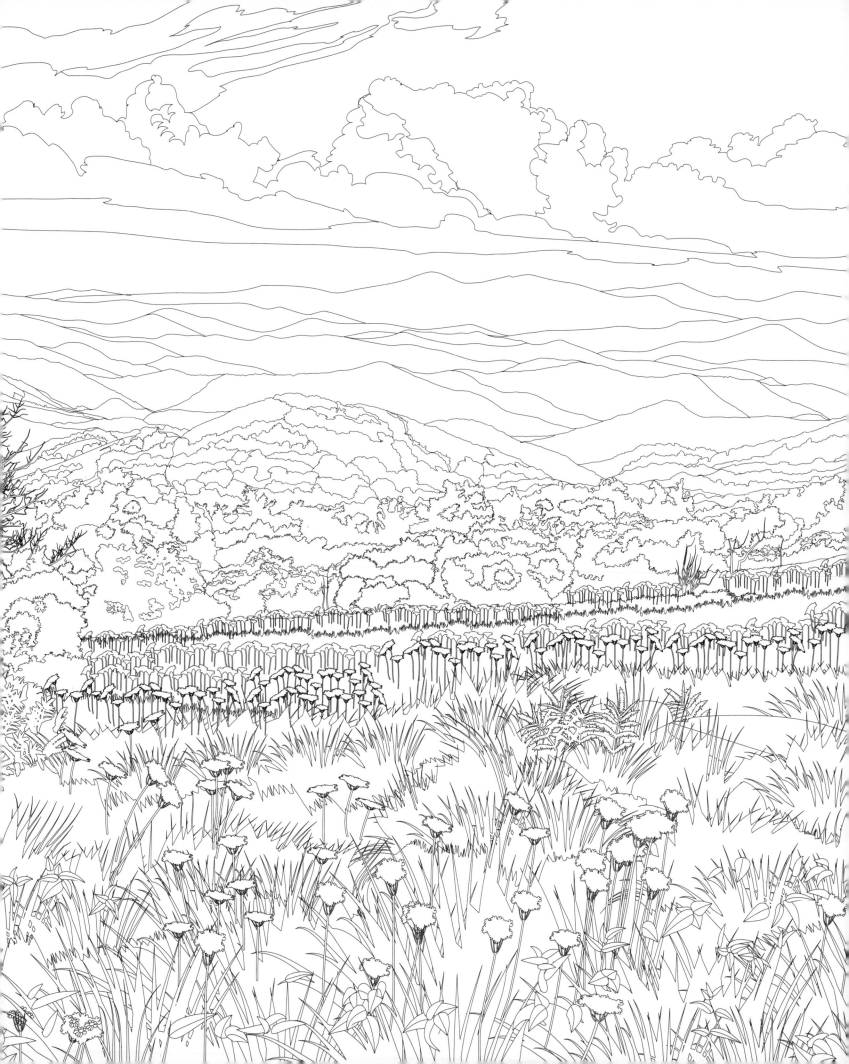

BUTTERFLY CONSERVATORY, AMERICAN MUSEUM OF NATURAL HISTORY, NEW YORK CITY

The Butterfly Conservatory is an annual exhibition at the museum that runs through the fall and winter. Here, live flowering plants, which grow in 80-degree temperatures, play host to as many as 500 tropical butterflies from the Americas, Africa, and Asia. Find swallowtails, morphos, longtails, and whites in a sealed environment that mimics their natural habitat. By the end of the exhibition, the butterflies have completed their natural lifespan, and the conservatory is dismantled.

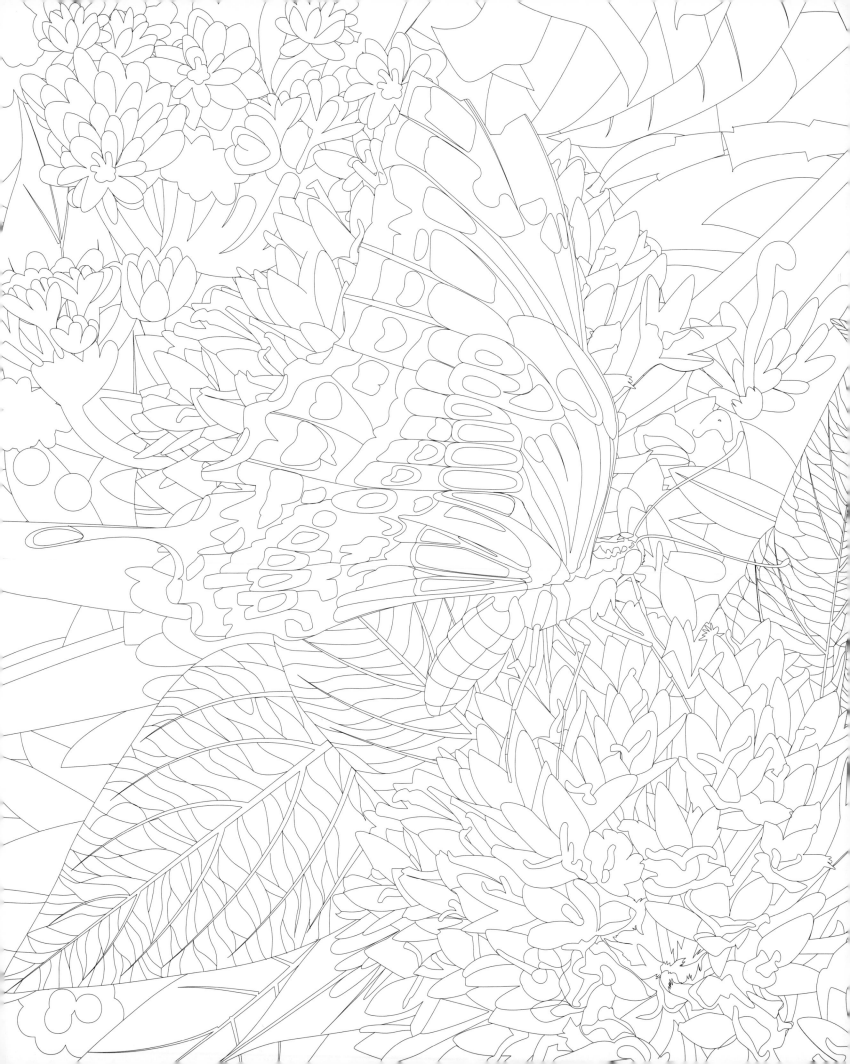

PADDLE STEAMER ON MISSISSIPPI RIVER, NEW ORLEANS, LOUISIANA

The current *Natchez* has been operating since 1975, but there have been many steamboats with that name. Several were captained by Thomas Leathers, a man determined to prove his was the fastest steamboat on the river. In 1870 he raced against the *Robert E. Lee*—and lost. By contrast, today's *Natchez* won the Great Steamboat Race in 1982 and has won every other race in which she has competed.

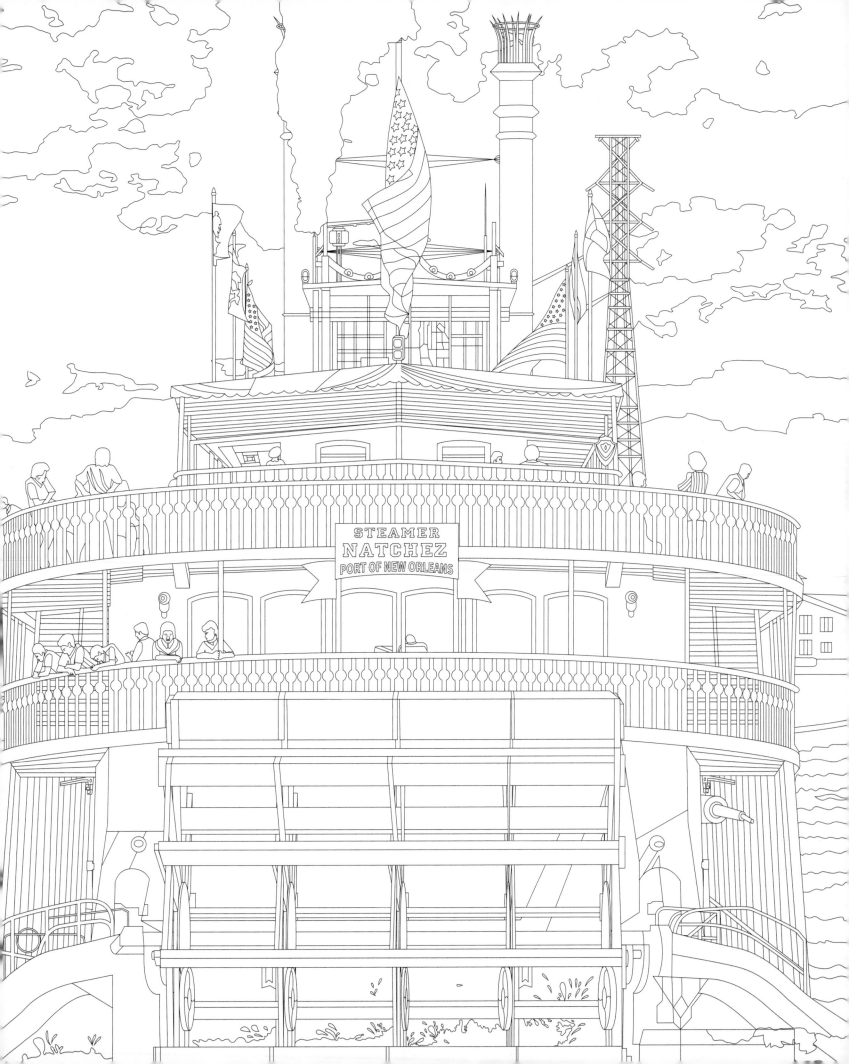

FRENCH QUARTER,
NEW ORLEANS, LOUISIANA

The French Quarter, or Vieux Carré, is the oldest neighborhood in the city, dating to 1718. Many of its buildings date from before the Louisiana Purchase of 1803 and are now protected by law. Most, though, are Spanish, not French, in style. Two fires in the late eighteenth century destroyed much of the original colonial architecture, which was replaced by the flat tiled roofs, elaborate ironwork, and bright colors so familiar today.

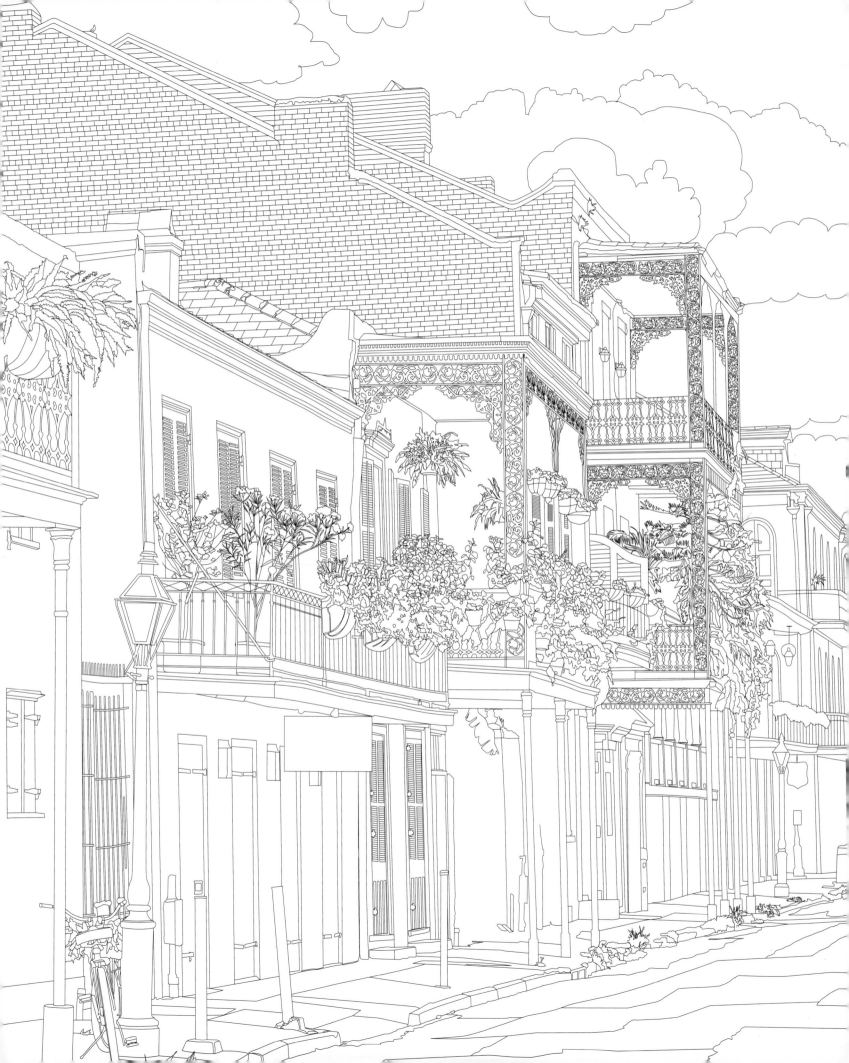

MAUI, HAWAII

Imagine a tropical beach, and most likely you'll envision a palm tree on the shore. Palm trees are found on each of the Hawaiian islands, and Maui has some unique to it. The poet W. S. Merwin has spent decades creating a palm forest on nineteen acres of former wasteland here. A living collection that is now one of the most important in the world, it includes more than 400 species of palms.

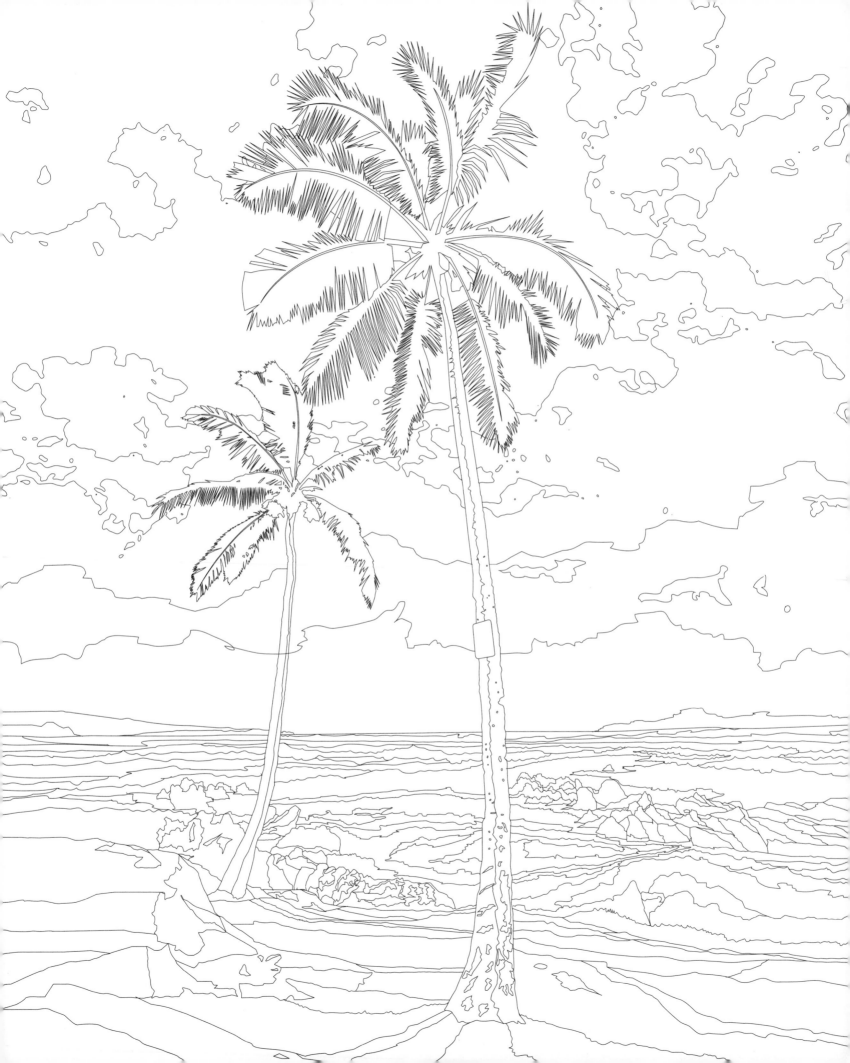

SERENITY LAKE, ALASKA

Alaska is the largest U.S. state by area, with coastlines on two oceans—
the Pacific and Arctic—and more than three million lakes. Serenity Lake is
certainly not the largest, but as the name suggests it's an idyllic setting that
attracts many visitors every year, especially for the fishing. It sits in a valley
that was settled by farmers only in the 1930s, as part of President Franklin
Delano Roosevelt's New Deal.

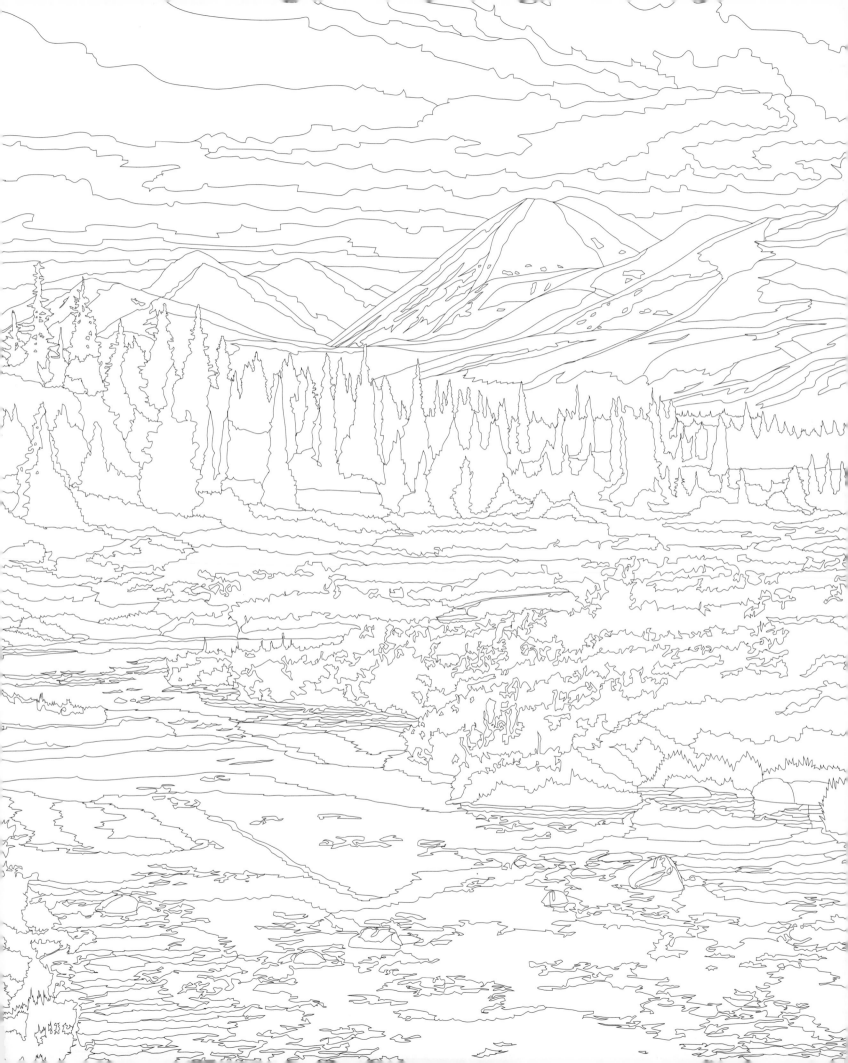

LOY'S STATION COVERED BRIDGE, THURMONT, MARYLAND

The Loy's Station Covered Bridge takes its name from a station on the now defunct Western Maryland Railroad. Built in 1848, it was originally all wood and a single 90-foot span, but this was reinforced with a concrete pier between 1929 and 1930. The bridge was added to the National Register of Historic Places in 1978—and burned down by an arsonist in 1991. Restoration took three years, at a cost of $300,000.

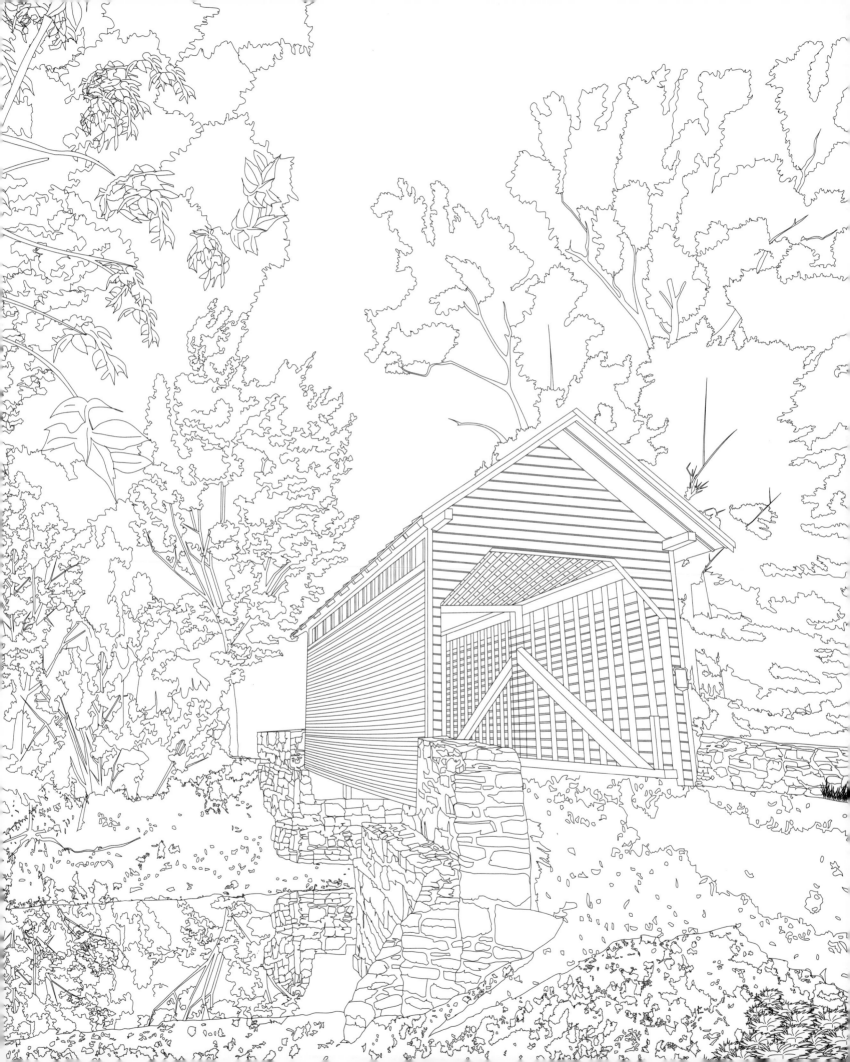

SPANISH MOSS, SOUTHERN UNITED STATES

Despite its name, Spanish moss is a flowering plant. Growing on larger trees, it takes its nutrients from the air and rainfall, which means it rarely kills its host. It may, though, hinder the tree's growth by reducing the amount of light that reaches the leaves. Spanish moss also plays host itself—to bats, rat snakes, and a jumping spider found on no other plant.

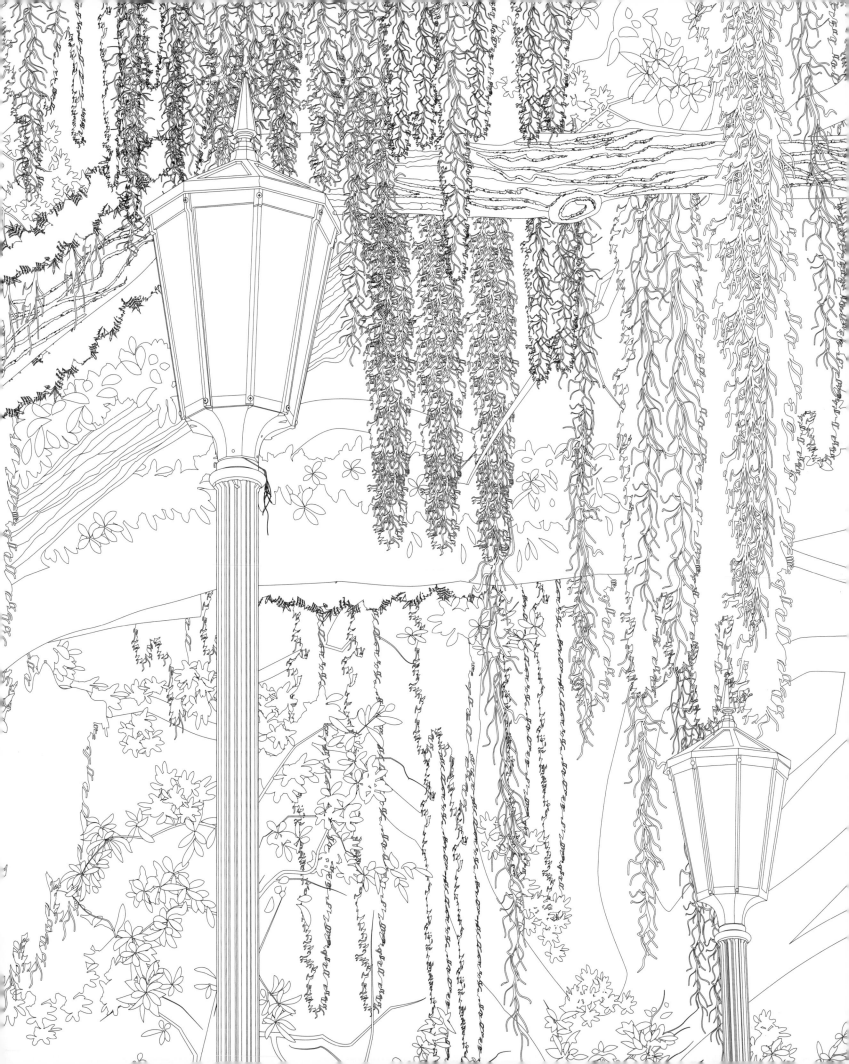

SNOQUALMIE FALLS, WASHINGTON, D.C.

For the Snoqualmie people, who have lived in the valley for centuries, the scenic falls are the site where Moon created the First Woman and First Man. Here, they offer their prayers to the Creator. Now listed in the National Register of Historic Places, the falls attract 1.5 million visitors every year, and will also be familiar to viewers of David Lynch's cult television series *Twin Peaks*.

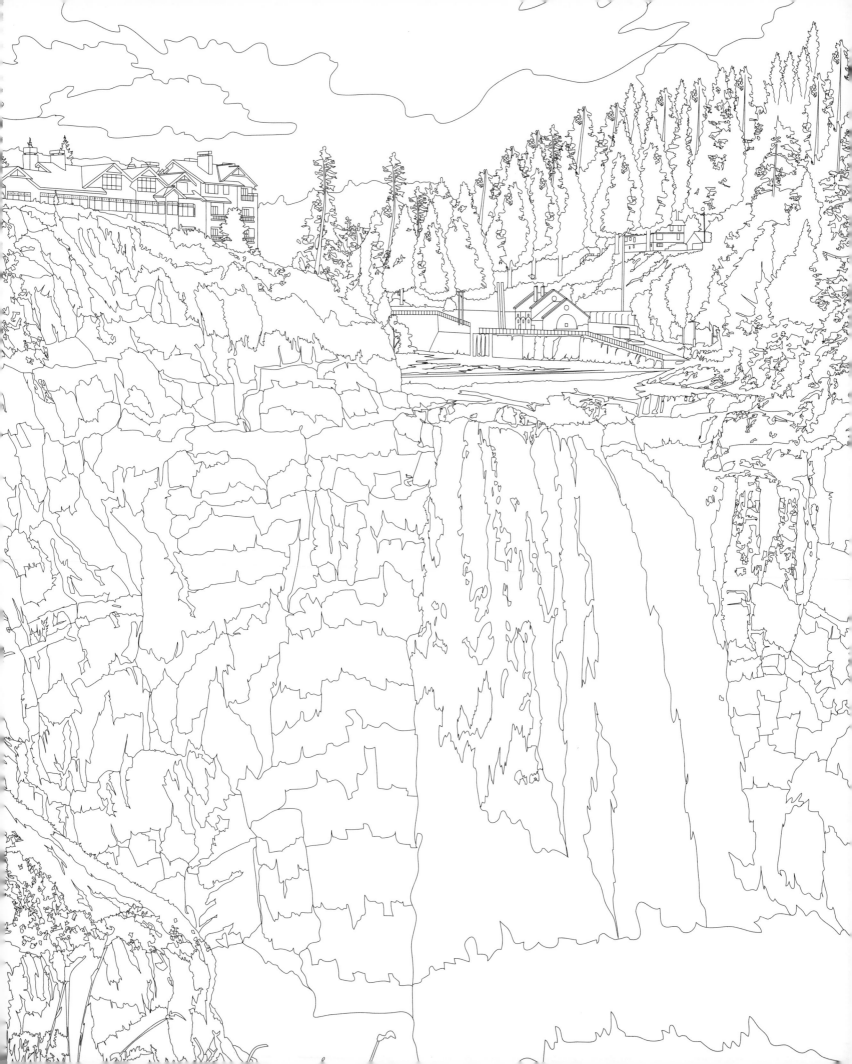

CLOUD GATE, CHICAGO, ILLINOIS

Artist Anish Kapoor was inspired by liquid mercury to create a sculpture he calls *Cloud Gate*—and which the people of Chicago call "The Bean." (The artist isn't impressed.) Made of stainless steel plates welded together, it has a surface so highly polished that no seams are visible. Reflecting both the clouds above it and the surrounding buildings, it is polished by hand twice a day to ensure the reflections remain unspoiled.

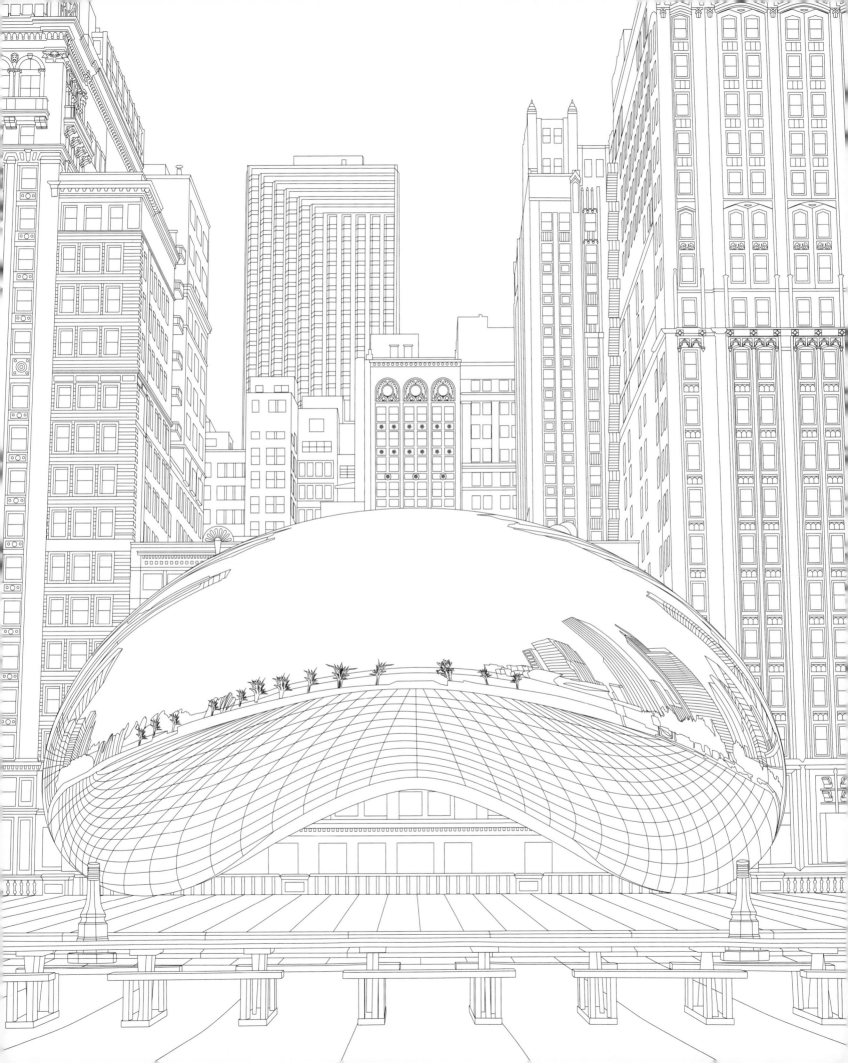

MOOSE IN MAINE

The moose is the largest of all the deer species, and stands up to 6½ feet tall. No animal in North America has such large antlers—up to 6 feet from end to end. Maine is one of very few U.S. states to have a healthy population of moose, and a good time to see these magnificent animals is late spring to midsummer. They can look a bit scruffy, though, as they shed their winter coats.

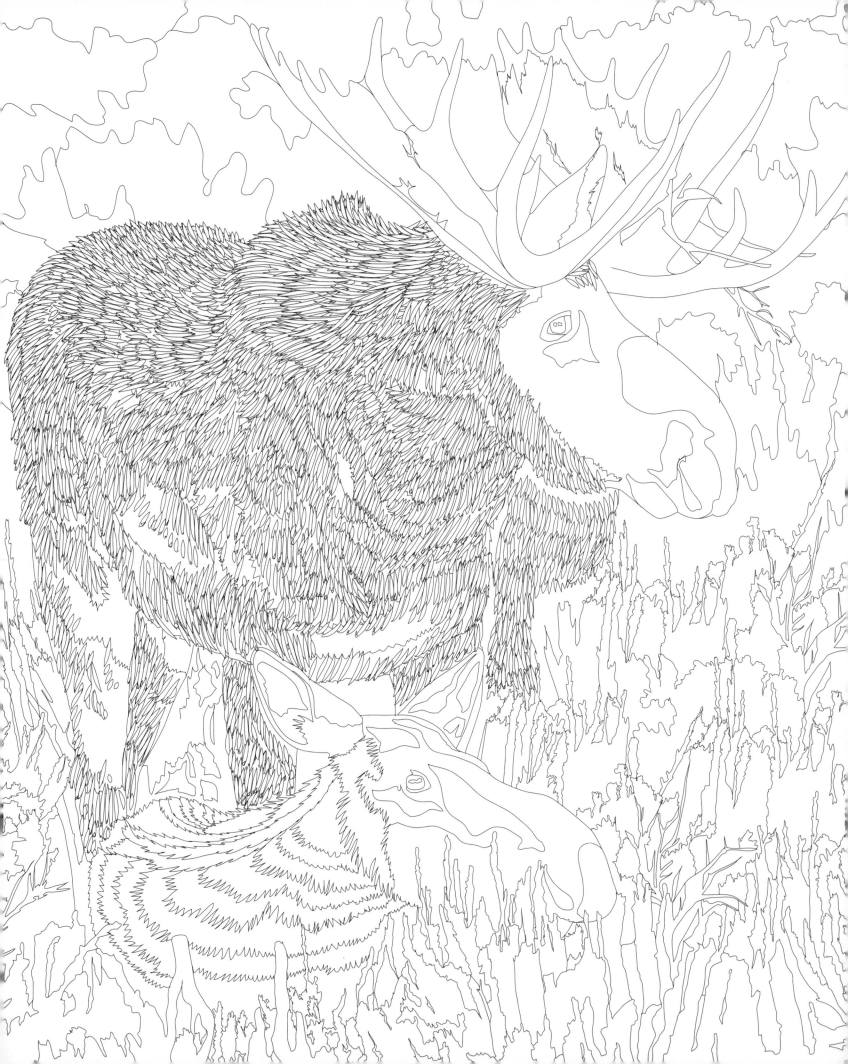

CARLSBAD CAVERNS NATIONAL PARK, NEW MEXICO

In 1898 a dense cloud of bats attracted the attention of a teenage boy. Deciding to investigate, Jim White found what he later described as "a whale of a big cave." Carlsbad Cavern is more than 1,000 feet deep, and within it lies the biggest underground chamber in the United States: the Big Room, about eight acres in size. It was burnt out of the limestone by sulfuric acid at least four million years ago.

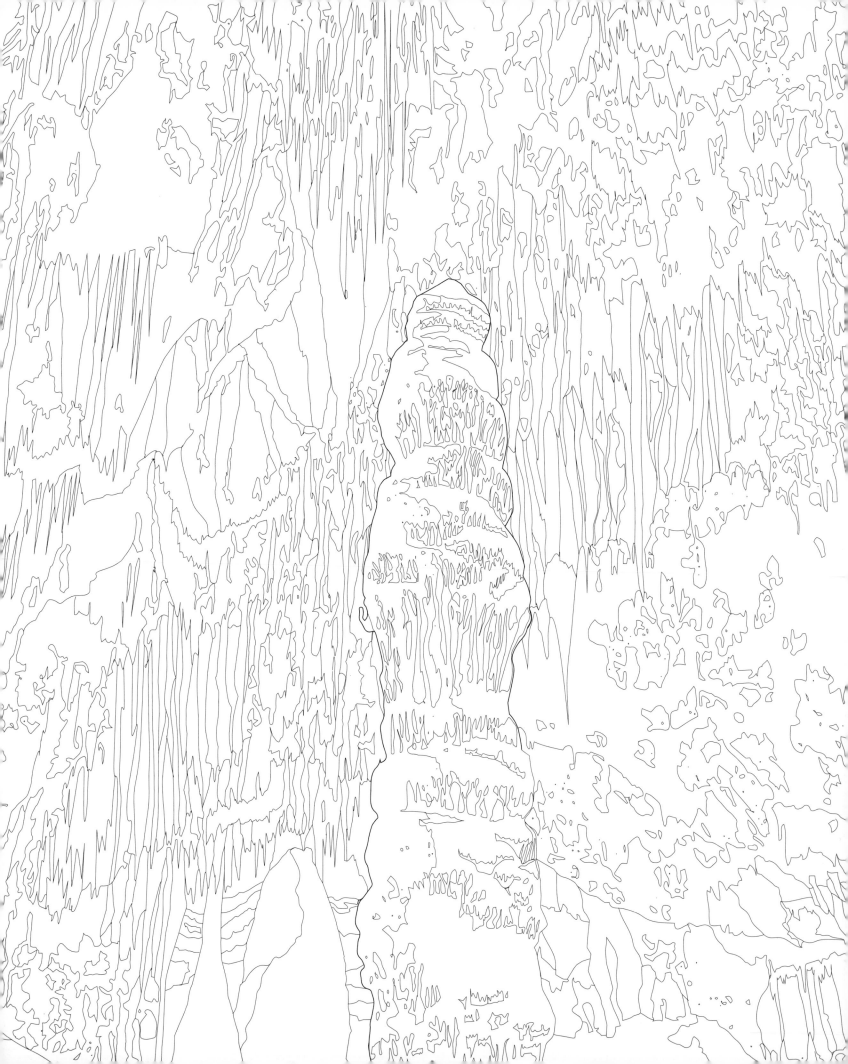

BODIE ISLAND LIGHTHOUSE, NORTH CAROLINA

There have been three lighthouses close to Bodie Island. The first was built in 1847—and began to lean shortly afterward. The second stood for only two years: retreating Confederate troops blew it up in 1861 to prevent its use as an observation post. The third was completed in 1872. It still stands, thanks to renovation work that began in 2009 but was interrupted by a hurricane before its completion in 2013.

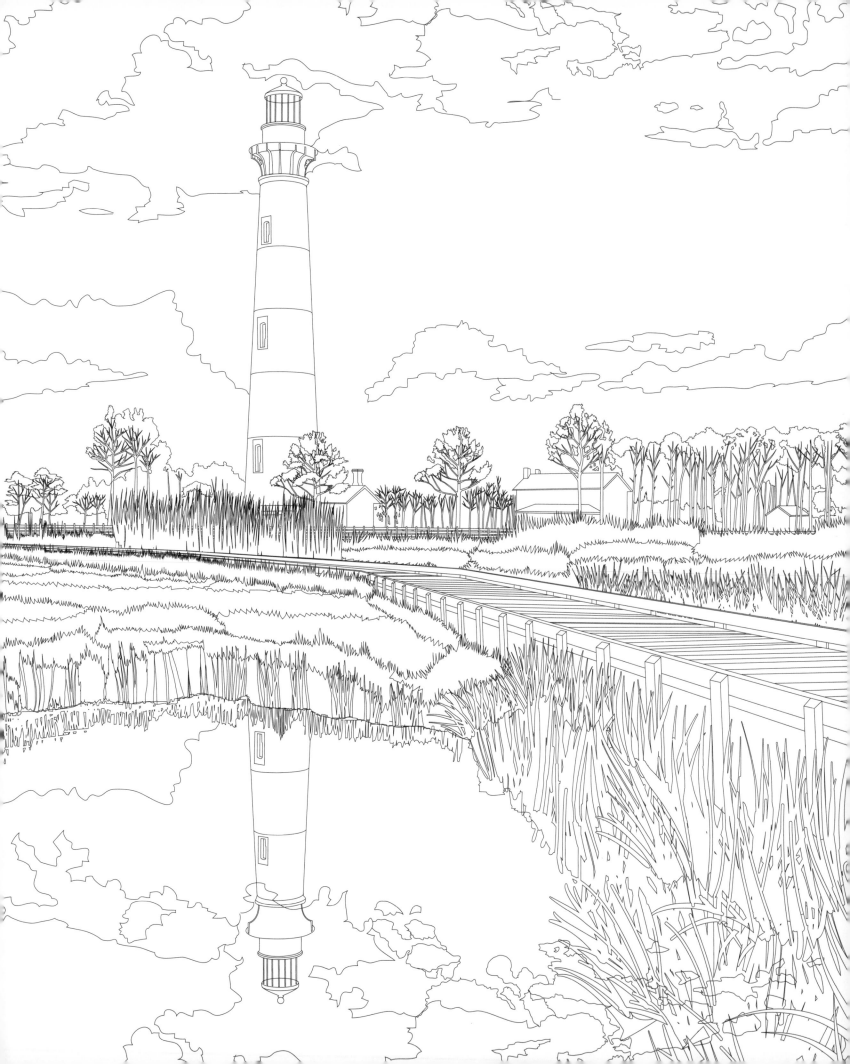

PUMPKIN PATCH

It seems that most people who buy pumpkins are buying them not to eat but to carve. And you've probably got Irish immigrants to thank for that. Not that they brought pumpkins with them—but they did bring the tradition of carving jack-o'-lanterns. Pumpkins in the New World were plentiful, large, and much easier to carve than turnips or other root vegetables.

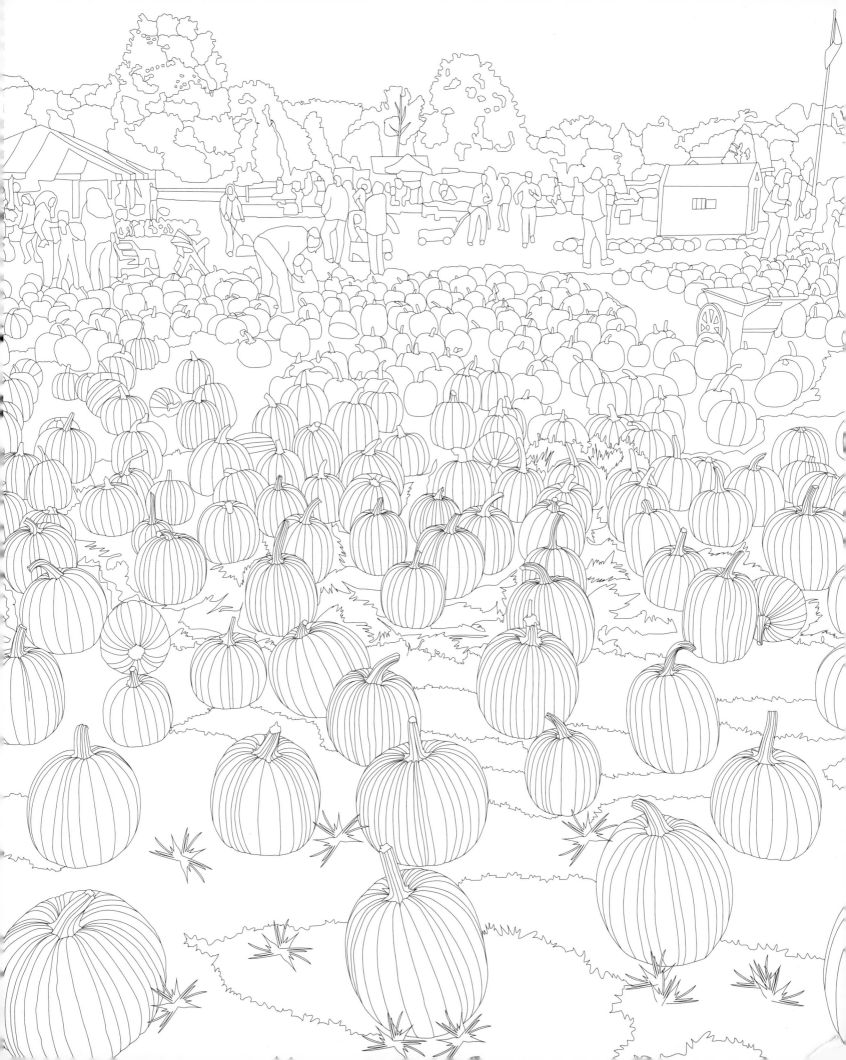

HALF DOME, YOSEMITE NATIONAL PARK, CALIFORNIA

While we call it Half Dome today, the Ahwahneechee called it "Cleft Rock." Both names reference its distinctive shape: Smooth and round, it has one sheer face, like a dome cut in half. Rising 5,000 feet above Yosemite Valley, it was long assumed to be inaccessible. A report from 1865 said as much, which was all the challenge that climber George Anderson needed. Barefoot and drilling iron spikes into the rock as he went, he took two days to finally reach the summit.

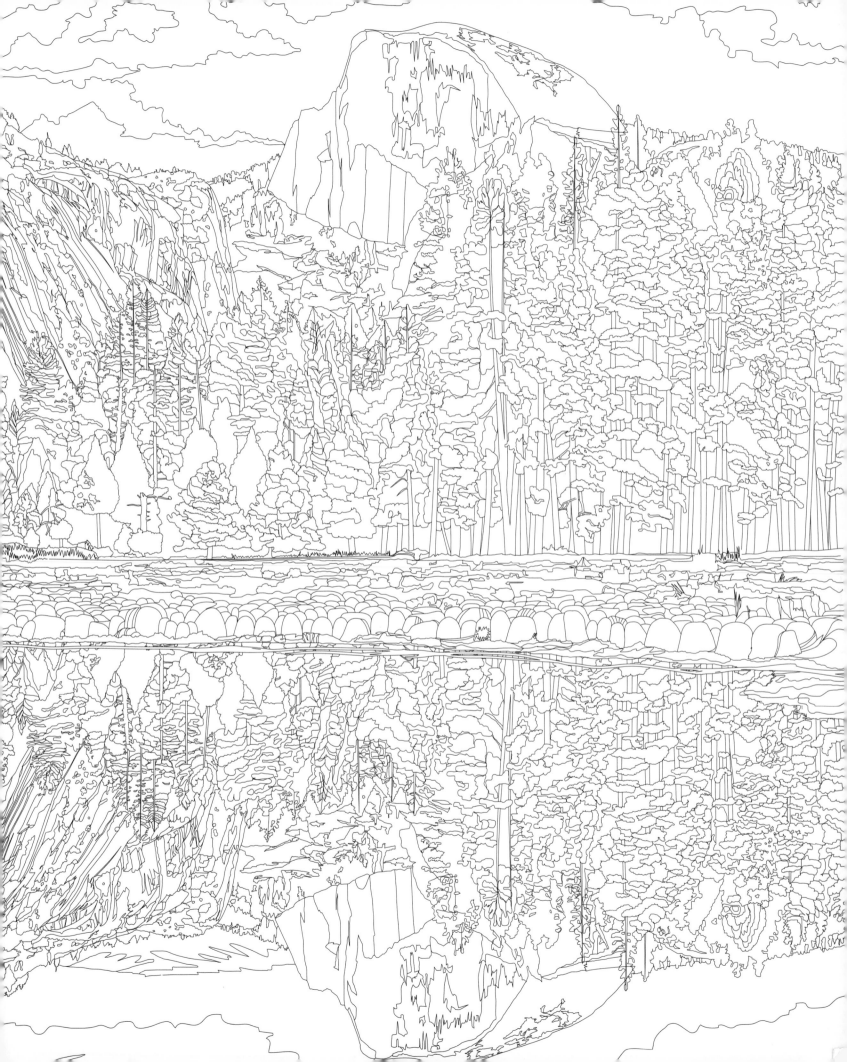

WAITS RIVER, VERMONT

New England is famous for its white churches, most dating from the eighteenth and nineteenth centuries. They were built by local craftsmen (at that time, there were no trained architects in the United States). Traditional designs were their inspiration, and it wasn't long before the churches became iconic. Long before the American public began to preserve the churches' heritage, local congregations were taking care to conserve them.

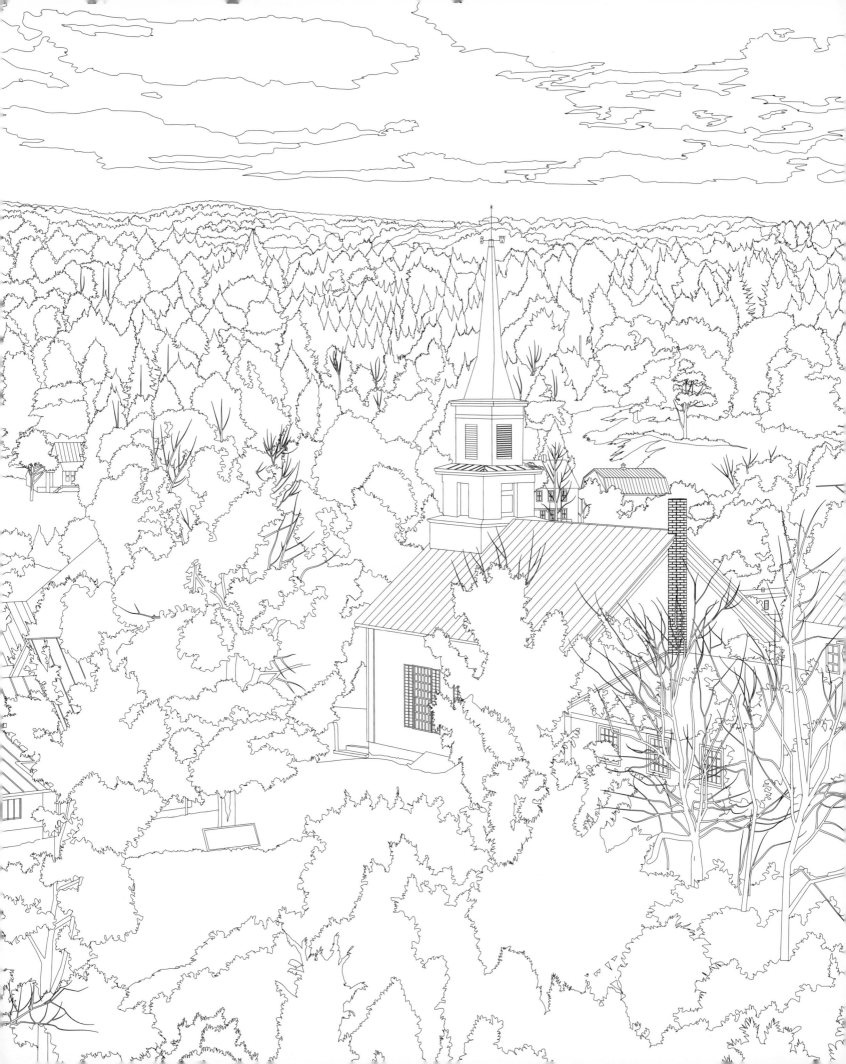

MANHATTAN BRIDGE, NEW YORK CITY

First opened on New Year's Eve 1909, the Manhattan Bridge is a suspension bridge that carries automobiles on its upper level, and trains, cyclists, and pedestrians on its lower level. The imposing arch and colonnade that stand at its entrance on Lower Manhattan were very much an afterthought—proposed only after the bridge itself had been completed, and not finished until 1915.

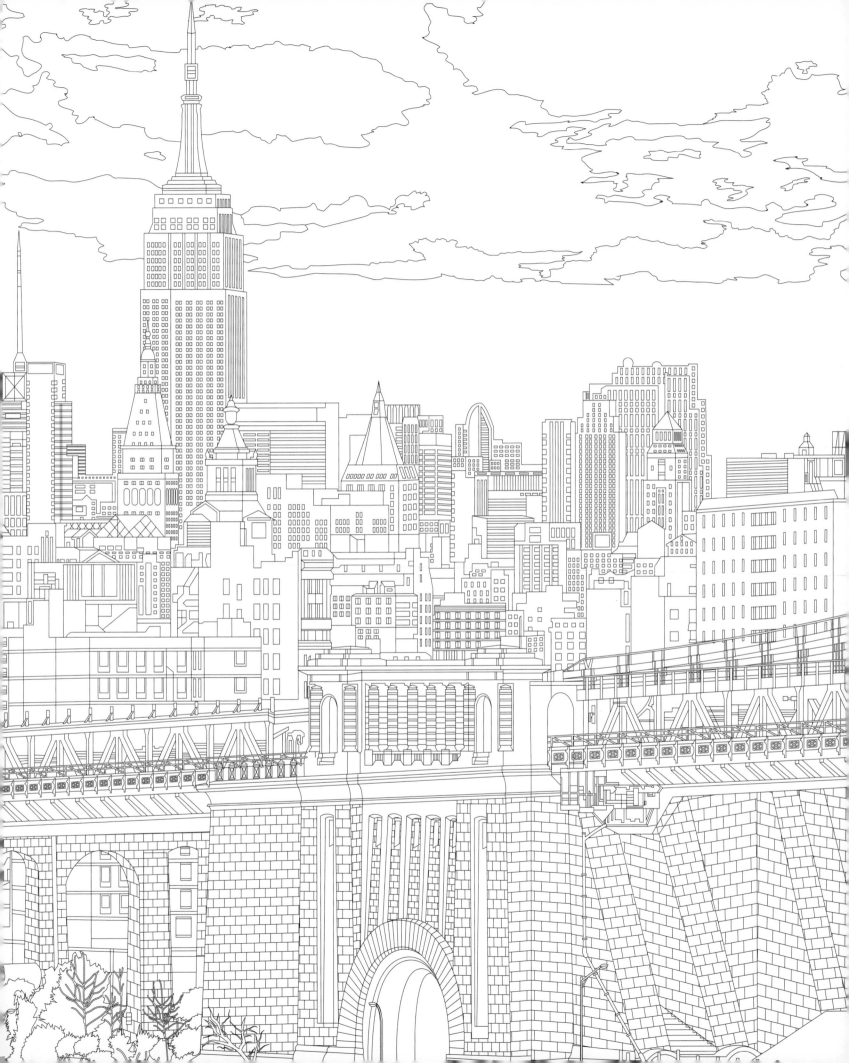

SLEEPY HOLLOW FARM, WOODSTOCK, VERMONT

It's more than 200 years old, and Sleepy Hollow Farm in rural Vermont has become a photographic icon. Visit with your camera, and you're unlikely to be on your own—particularly in the fall as the leaves change color. Early morning offers the best light. It stands near Woodstock, a town first settled in 1768 and which now has a population of just over 3,000.

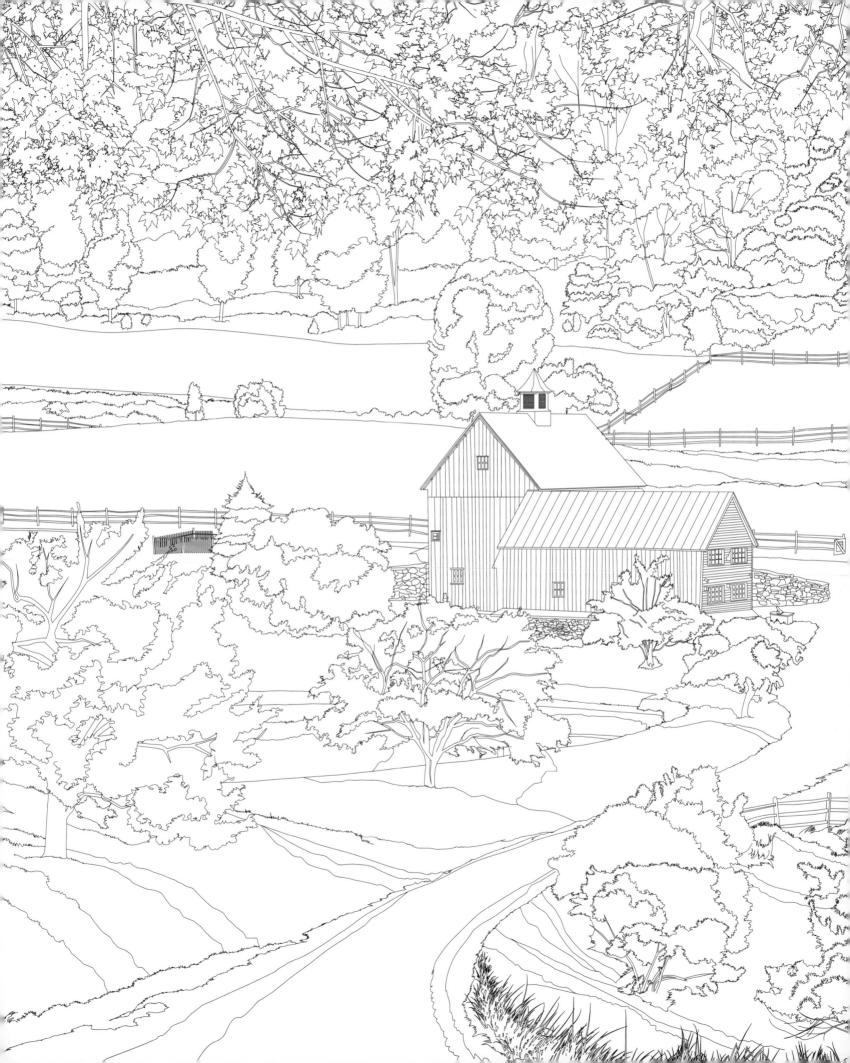

WAGNER FALLS STATE PARK, MICHIGAN

Wagner Falls is a waterfall in Alger County, Upper Michigan. A short trail leads to an observation deck overlooking the falls, which are fed by the waters of Wagner Creek, and you stand among virgin pine and hemlock trees. Renowned for its beauty, it now enjoys protection as a legally designated natural area. The falls are particularly worth visiting during the autumn when the leaves change color.

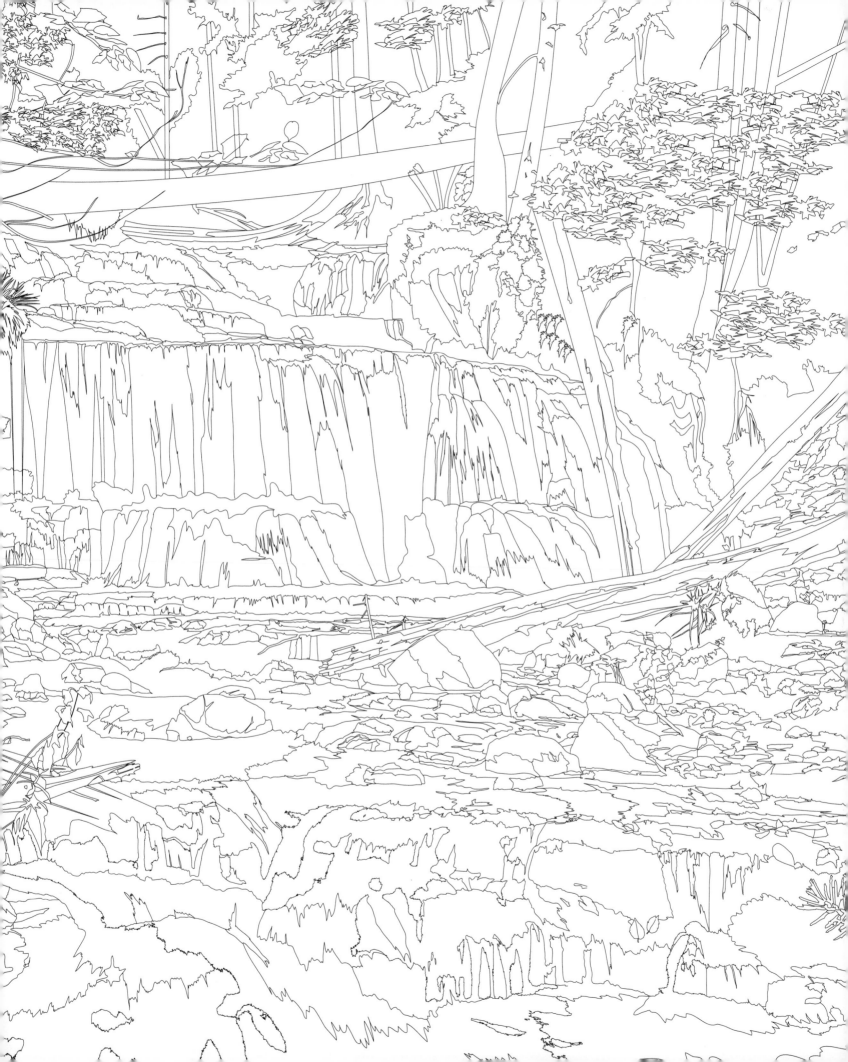

CRESCENT BEACH, ECOLA STATE PARK, OREGON

Between Ecola Point and Chapman Point stands Crescent Beach. Follow the mile-long trail to visit the small, secluded beach, and at low tide you'll find tide pools to explore. Offshore you'll likely see pelicans, seals, and sea lions. The beach is located in Ecola State Park, where Lewis and Clark's Corps of Discovery trekked across difficult terrain to see a beached whale.

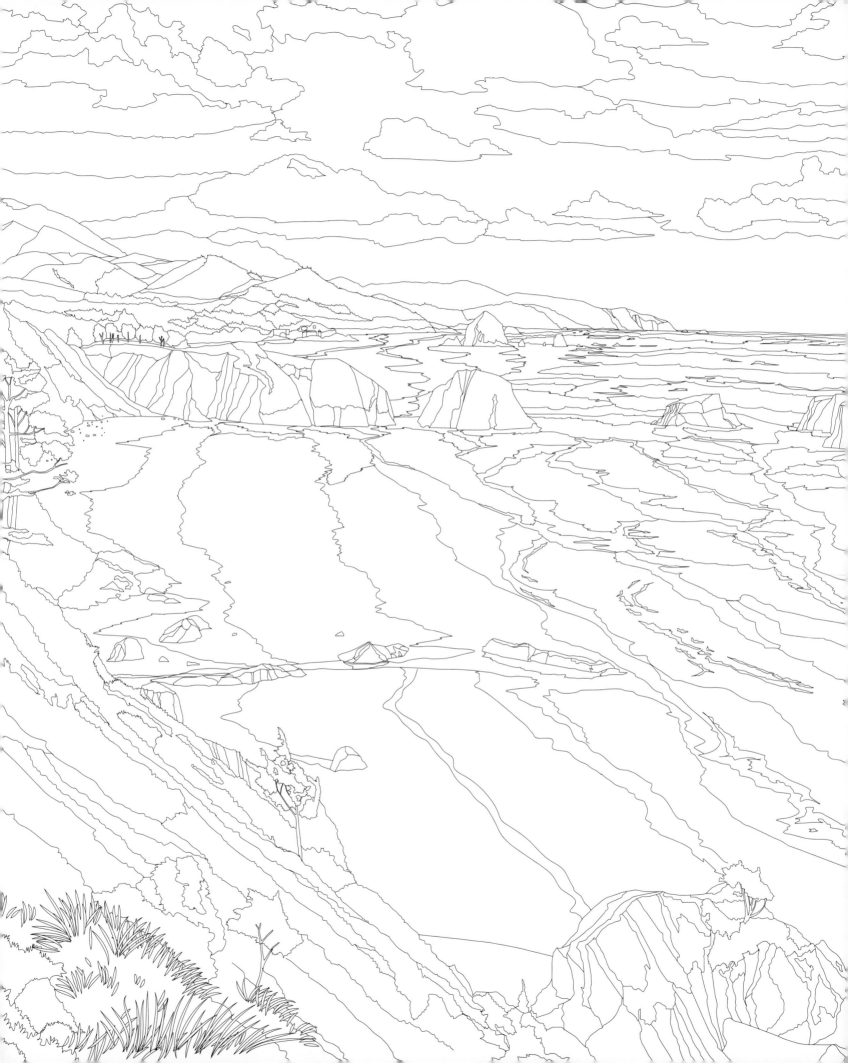

CENTRAL PARK, MANHATTAN, NEW YORK CITY

As the population of New York quadrupled in the first half of the nineteenth century, the need for a public park became ever more obvious. The eventual design was inspired by London's Hyde Park. By the time it was completed in 1873, more than 18,500 cubic yards of topsoil had been brought in from New Jersey, and the area had been planted with more than four million trees, shrubs, and plants.

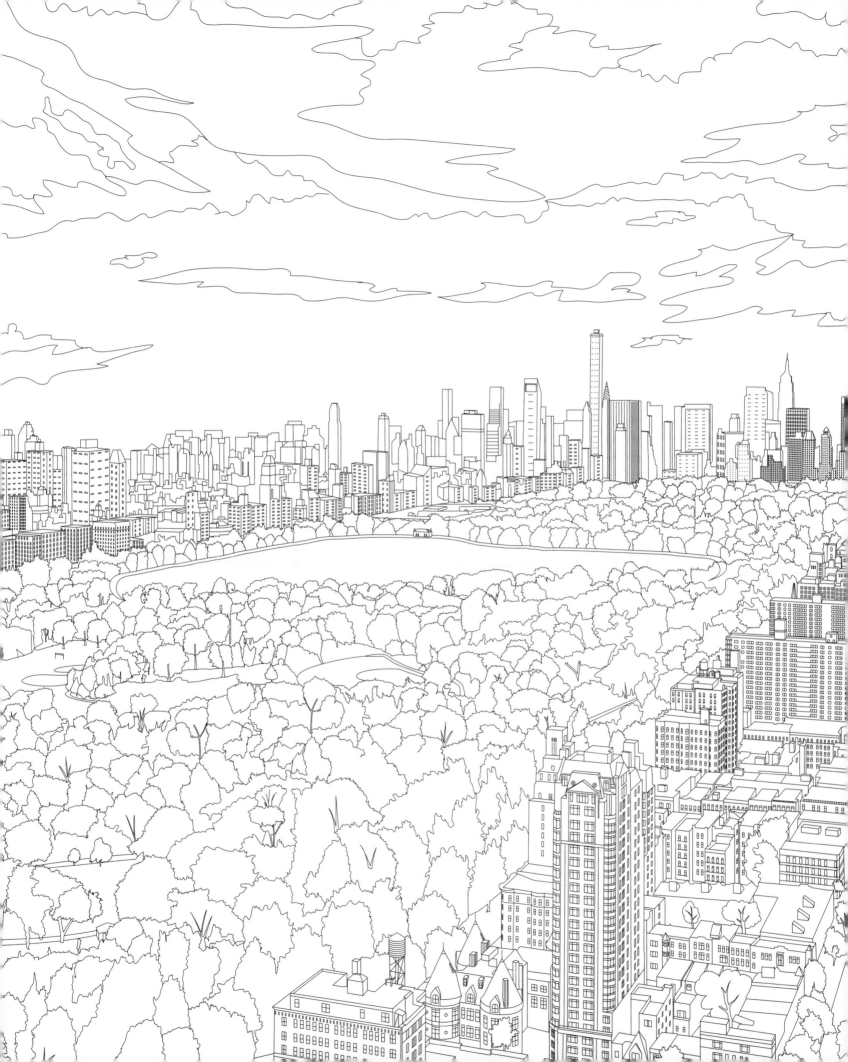

WHITE-TAILED DEER FAWNS, MONTANA

White-tailed deer are found across North America and are particularly populous in Montana. The name comes from the underside of their tail, which the deer display when sensing danger. Only young fawns have white spots on their reddish coats, which help them to blend in with the forest, where they take refuge from the summer sun.

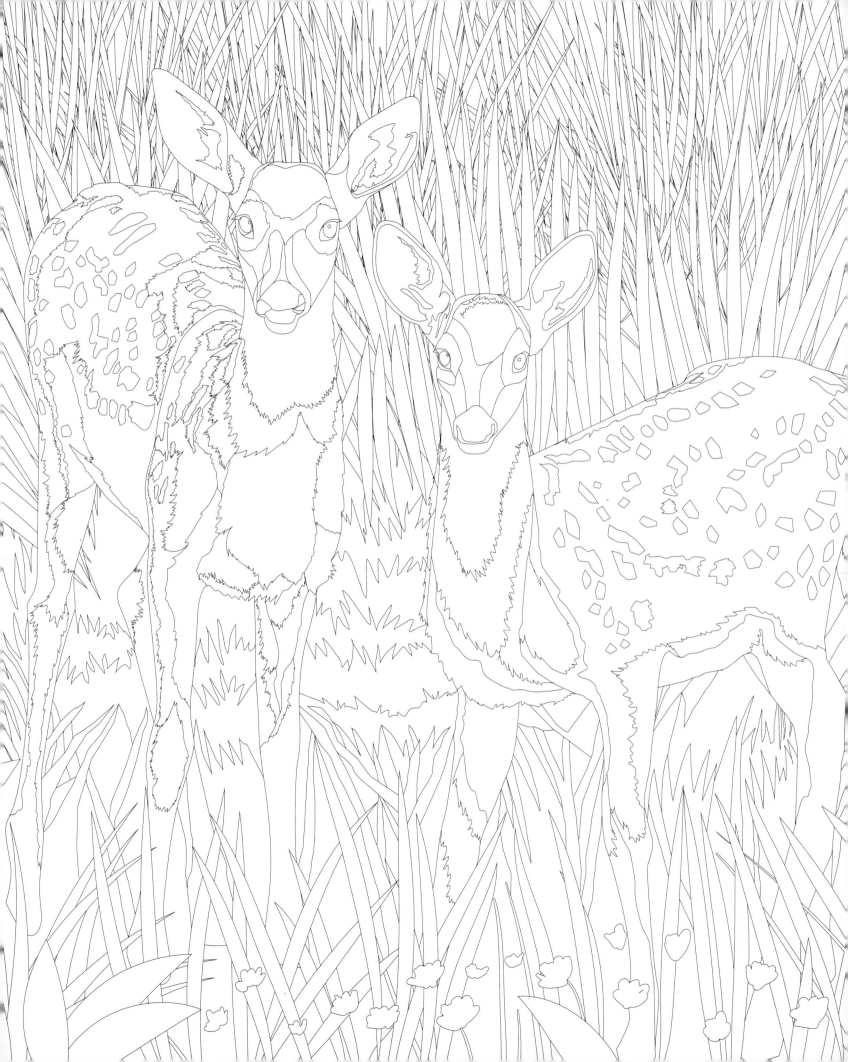

ALBUQUERQUE INTERNATIONAL BALLOON FIESTA, NEW MEXICO

The Albuqerque International Balloon Fiesta is the largest balloon event in the world. Indeed, when the number of balloons reached more than a thousand in 2000, a limit had to be introduced, and now only 600 are allowed. Highlights of the festival, which lasts for nine days in early October, are a daily Dawn Patrol show; Mass Ascension, when all the balloons launch in two waves; and "Glowdeos," with the propane burners illuminating the night sky.

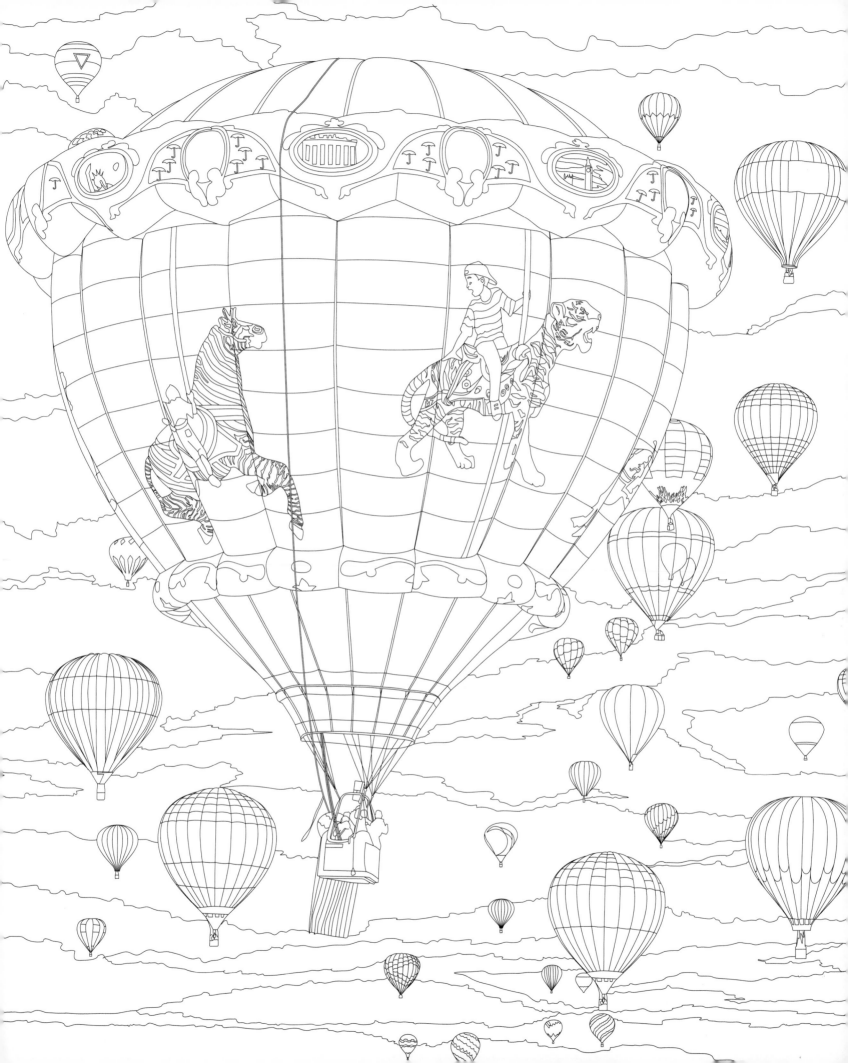

WILDFLOWERS, YELLOWSTONE NATIONAL PARK, WYOMING

Wildflowers herald the arrival of spring in Yellowstone National Park. Color splashes across the valleys from the many dozens of flowering plants found here—the whites of phlox, blues of the lupin and penstemon, reds and oranges of the paintbrush, and yellow of the glacier lily. The latter is a favorite of the grizzly bear as it awakens from hibernation.

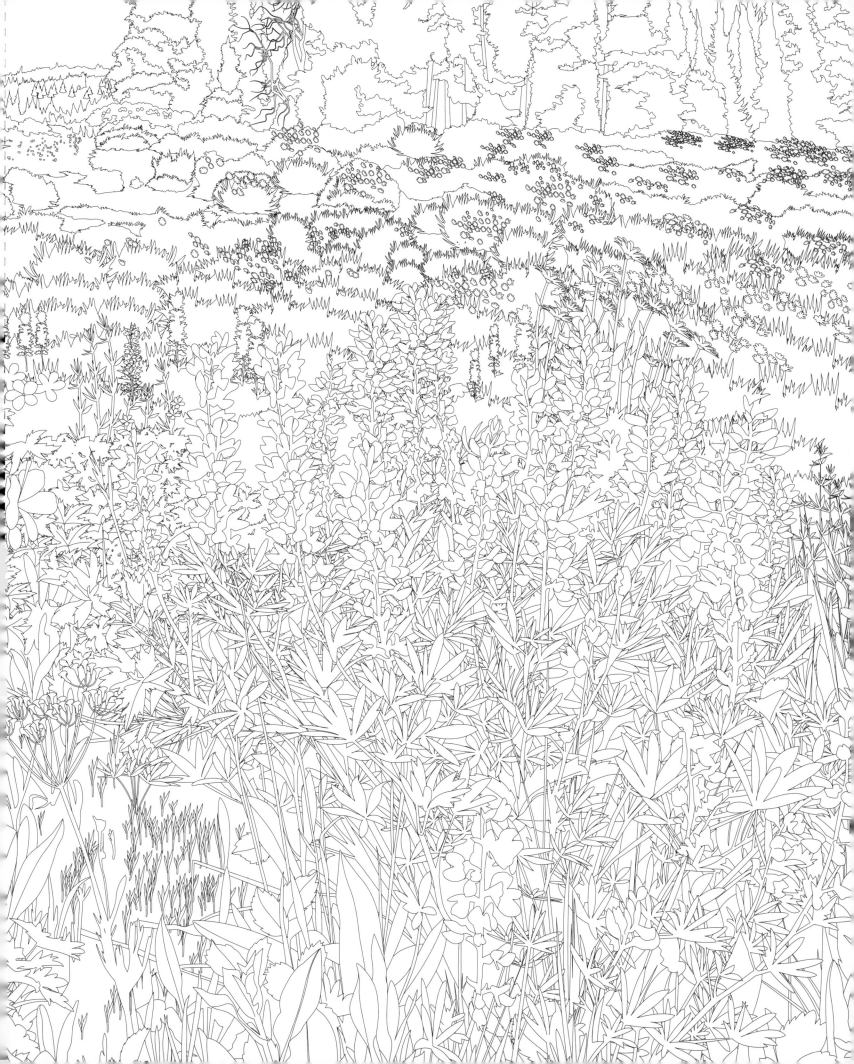

BRANDYWINE FALLS, CUYAHOGA VALLEY NATIONAL PARK, OHIO

It's not clear how the waterfall got its name—one story suggests that a bottle of brandy was the prize for the person who came closest to guessing its height. What is certain is that its rock formations can be read as easily as a geological textbook. Over the years, the waters have worn away the rock to reveal yellow-brown sandstone, about 320 million years old, sitting above red shale, about 400 million years old.

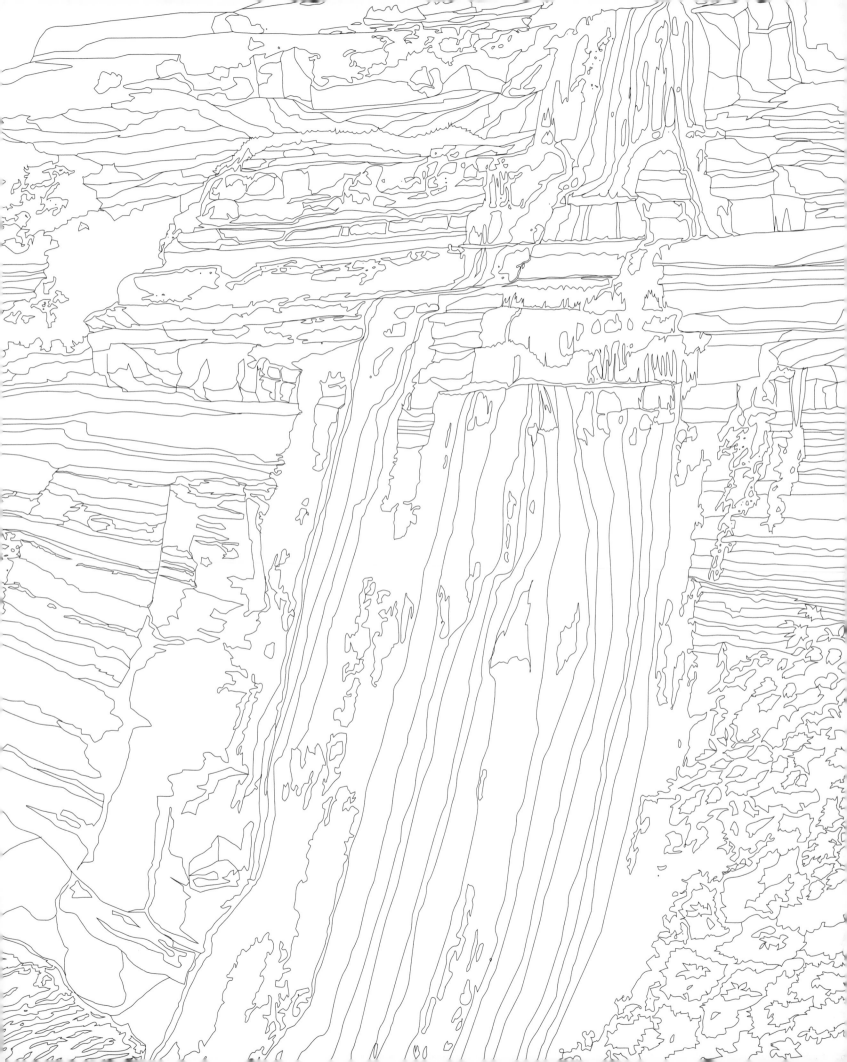

WINDMILL IN THE MIDWEST

The windmills we associate with the midwestern United States first appeared in large numbers in the 1870s as more and more settlers began to farm the land. Between the 1880s and 1920s, they provided the power for pumping water and operating feed grinders and saws. Their use declined following the Rural Electrification Act of 1935, but they still stand to this day thanks to the efforts of locals keen to preserve history.

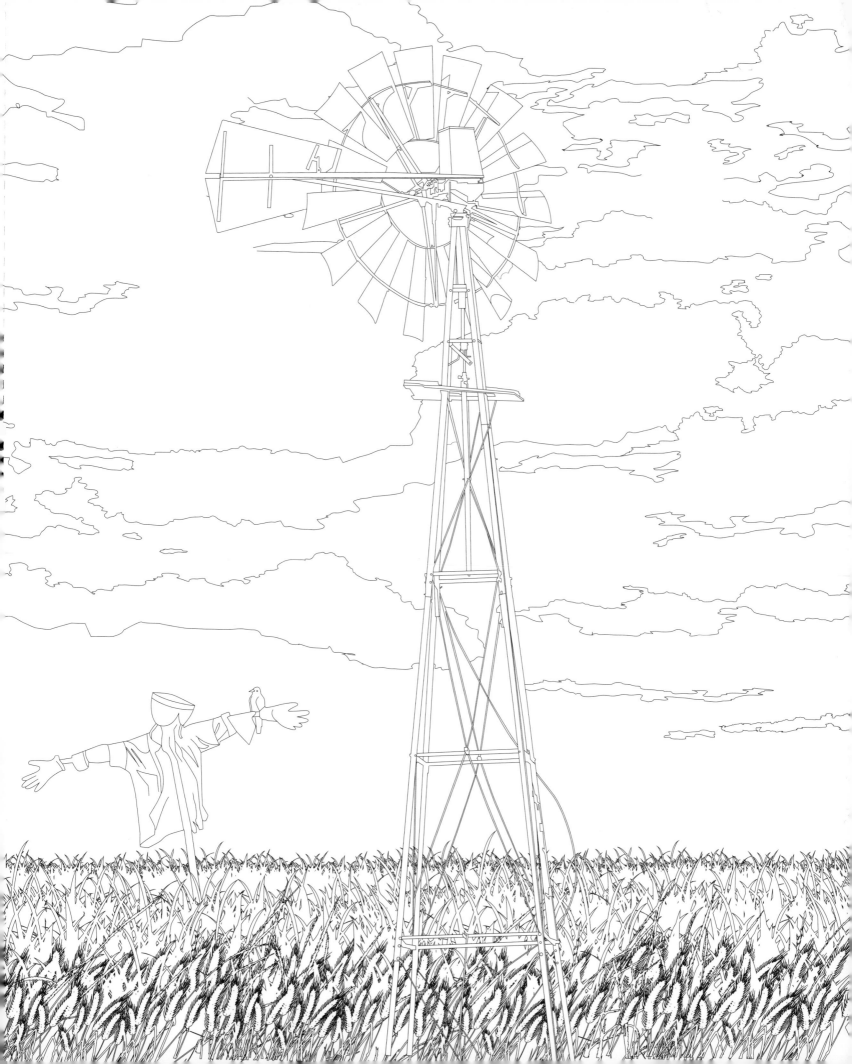

Portable Press
An imprint of Printers Row Publishing Group
10350 Barnes Canyon Road, Suite 100, San Diego CA 92121
www.portablepress.com

Portable Press
Publisher: Peter Norton
Publishing Team: Gordon Javna, JoAnn Padgett, Melinda Allman, Jay Newman, Trina Janssen, J. Carroll, Aaron Guzman

ISBN: 978-1-62686-757-4

Printed in China

20 19 18 17 16 1 2 3 4 5

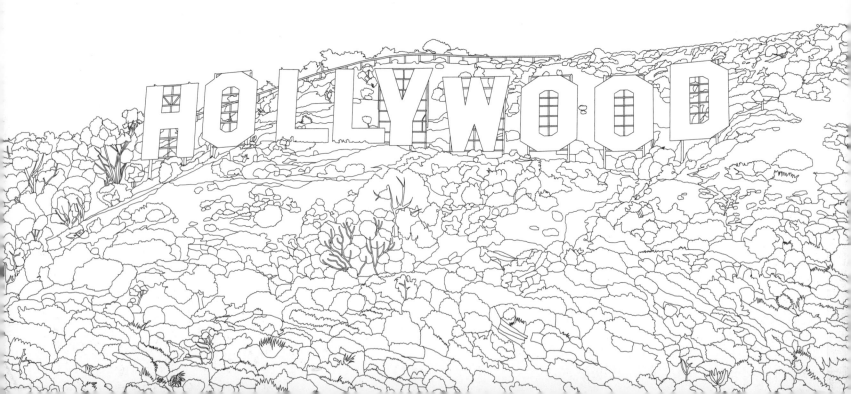